FAN PHENOMENA

STAR WARS

EDITED BY
MIKA ELOVAARA

Credits

First Published in the UK in 2013 by Intellect Books,
The Mill, Parnall Road, Fishponds, Bristol, BS16 3JG, UK

First Published in the USA in 2013 by Intellect Books,
The University of Chicago Press, 1427 E. 60th Street,
Chicago, IL 60637, USA

Copyright © 2013 Intellect Ltd

Editor: Mika Elovaara

Series Editor and Design: Gabriel Solomons

Copy Editor: Michael Eckhardt

Inside front cover image: Fangirl photographer/
blogger Savanna Kiefer (www.plcohmy.com).
Inside back cover image: Original artwork by Rachelle
Porter, created for and posted alongside 'About Turn'.

A Catalogue record for this book is available from
the British Library

Fan Phenomena Series
ISSN: 2051-4468
eISSN: 2051-4476

Fan Phenomena: Star Wars
ISBN: 978-1-78320-022-1
ePUB ISBN: 978-1-78320-098-6
ePDF ISBN: 978-1-78320-097-9

Printed and bound by
Bell & Bain Limited, Glasgow

Contents

Acknowledgements

My journey in the galaxy far, far away has been both a personal and professional one. Setting out to compile a book on *Star Wars*, one is faced with a positive dilemma: the world is full of potential contributors – how to find the right group? In hindsight, though my methods of arriving at the final roster of contributors to this book were disparate, I believe what we have in our hands is a uniform presentation of various topics on a saga we all care about. I would like to express my sincerest gratitude to all the contributors of this book; you have been great to work with and I am grateful for the opportunity to have done so. I would like to thank Intellect for allowing me the opportunity to work on a much beloved topic, and more specifically, James Campbell for his encouragement and advice and our series editor, Gabriel Solomons, for his instruction, guidance, support and leadership throughout the process. I would also like to thank all my students in *Star Wars – A Complete Saga?* over the years. Teaching the class and discussing the saga with you has been an important part on my professional journey with the saga. I would also like to thank my mentors and colleagues who have inspired me to pursue my own path in the maze of academia. Clearly, that path has not been one to the dark side, but one supported by 'a Force that guides us'. On a more personal note, I would not be working on this book without the support of my closest friends and most importantly, my family. My late mother and father took me to the cinema for the first time to see *Empire Strikes Back* and bought me the AT-AT for Christmas at the age of six – that's when it all started; my sister endured our Battles of Yavin, Hoth and Endor looking out and caring for me; and my immediate family, my wife and three children, share my interest in and passion for the saga on various levels, and are my greatest source of inspiration every day. Thank you for your love and support.

Mika Elovaara, Editor

Introduction
Mika Elovaara

→ It was during the same week in January 2012 that I was approached by Intellect about editing this book that I also received an invitation to appear as a guest on a TV show called *Ridley Scott's Prophets of Science Fiction*, for an episode on George Lucas. Request for one solidified the agreement to work on the other, and I cannot say which one came first.

And it really doesn't matter: my journey with the phenomenal saga George Lucas created has been spontaneous, both personally and professionally, and writing this introduction, I know it has been such for most people around the world who feel a bond with the saga, whether personally, professionally, or both. By all means, his relationship to the saga must have been rather spontaneous to George Lucas himself; who could have planned or predicted such a long-lasting, global phenomenon? For me, at the moment when I was considering the contents of this book and thinking about contributors, and getting ready to fly to Los Angeles to discuss the 'prophecy' of George Lucas in front of TV cameras, I realized this introduction to *Fan Phenomena –Star Wars* has been in the making for me since 1980. *Empire Strikes Back* (Kershner, 1980) was the first movie I saw in the theatre, at the age of five; I got the AT-AT for Christmas the same year and spent much of my childhood collecting and playing with the *Star Wars* action figures. I never cared for any others (sorry, Skeletor and He-Man), all I needed was the *Star Wars* figures; I played the first *Star Wars* arcade game until I ran out of allowance, had lightsaber duels with friends and rewatched the Original Trilogy films over and over again. I never grew too old for the saga – in 1997 I made a trip to Washington, D.C. to see the twentieth anniversary exhibition in the National Air and Space Museum, and proudly posed next to the display cases with costumes as a twenty-something 'serious' grown up. When I started my career as a teacher, it took me all but three weeks to find the opportunity to incorporate my *Star Wars* passion into work: I taught a three-lesson unit on the saga at a Finnish high school during the first month of my first full-time teaching job. That unit became a staple in one of the high school's English classes with a cultural studies focus, and I took it to 'the next level' so to speak when I developed *Star Wars – A Complete Saga?* for the Graduate Liberal Studies Program at UNCW in the autumn of 2007. As one might expect, a graduate level class completely on *Star Wars* was met with both awe and scepticism, but that did not discourage me from going through with the plan. Since then, I have taught the class both on campus and online to men and women between nineteen and 50 years of age, and have consequently become more convinced that *Star Wars*, if anything in popular culture, warrants its own course for academic study, as it surely also warrants a plethora of literature examining it.

While it is undeniably a mere individual anecdote, I know the path of my *Star Wars* fandom speaks for a more collective experience as well; the fan phenomenon of *Star Wars* is, indeed, personal and professional for a lot of people around the world. When one considers the contents of this book, the realization one arrives at is that we are not alone with our personal-becomes-professional anecdotes. Just think about the influence and inspiration of George Lucas and *Star Wars* to scientists and film-makers who grew up with the saga: our world would be dramatically different if we did not share, as global culture, the presence of *Star Wars* and its fans. In the following pages, a variety of fans of *Star Wars* take on the honour and challenge to write about the various aspects of *Star Wars* fandom to you. Our chapters from Jason Scott's 'Star Wars as a character-oriented franchise' to Jason Davis and Larry Pakowski's 'The influence of the Force' demonstrate the depth and detail of the fan phenomenon, recounting and explicating a

Introduction
Mika Elovaara

variety of issues, but also raising more questions for us all to ponder.

In Chapter 2, Jason Scott explains the complex relationship between the *Star Wars* films and other authorized versions within the saga, and their emotional resonance and social use by fans. Among others, he states that '*Star Wars* characters continue to be used in complementary ways by both Lucas and the fans, as heroes and villains, mythic archetypes, icons, identities and objects of affection', and it is all due to the fans' continuing affection for the characters and for what happens to them in films. This is inspired and facilitated by the character-orientedness of the saga, which, according to Scott, offers the main ingredient for the social glue for *Star Wars* fandom.

In Chapter 3, Jonathan DeRosa takes us to the world of *Star Wars* fashion in its various forms. Leaning on numerous examples for support, he concludes that *Star Wars* 'still offers such a profound impact on today's society that we make the conscientious decision to spend money to sport our love for some galaxy far, far away'. DeRosa's chapter makes it quite explicit that *Star Wars* fashion is much more than just character dress-up for Halloween or cosplay: there are all kinds of products for fans, from clothing and jewellery to wallets, watches and other accessories, all of which communicate to the viewers that *Star Wars* is part of their identity, that 'By the way I dress, I identify with myself and with others by how this movie phenomenon changed my life'.

In Chapter 4, Marc Joly-Corcoran and Sarah Ludlow discuss two very important areas of *Star Wars* fandom: fanfiction and fanfilms. As their chapter clearly demonstrates, there is a significant number of *Star Wars* fans to whom 'the desire to be involved with *Star Wars* goes beyond the official merchandise and TV spin-offs' – those who continue and expand on the narratives of the saga through fiction and film. Joly-Corcoran and Ludlow explicate that despite George Lucas' efforts 'to fully control how his films have been used since their release', thousands of fans around the world continue to produce their own narratives within and beyond those crafted by Lucas and the artists he has authorized to tell the stories of the saga.

In Chapter 5, Jason Scott take us through the evolution of interactive and immersive forms of *Star Wars*, from the early arcade games, through console and video and computer games to the plethora of options available today, including games utilizing the Internet in a variety of ways, such as massively multiplayer online role-playing games (MMORPGs). Chapter 5 also provides us a look into the broader and extensive presence of *Star Wars* on the Internet.

In Chapter 6, Erika Travis discusses one of the most intriguing and sociologically important aspects of *Star Wars* fandom: gender. She contends that 'although some may still consider *Star Wars* […] the domain of male fans, the claim is becoming less and less convincing as female fans continue to express their presence in the *Star Wars* community', and after reading her chapter, one is bound to agree with her position. As Travis explains, the saga's portrayal of female characters is complicated – in some ways traditional and in others progressive. She demonstrates that the place of female fans within

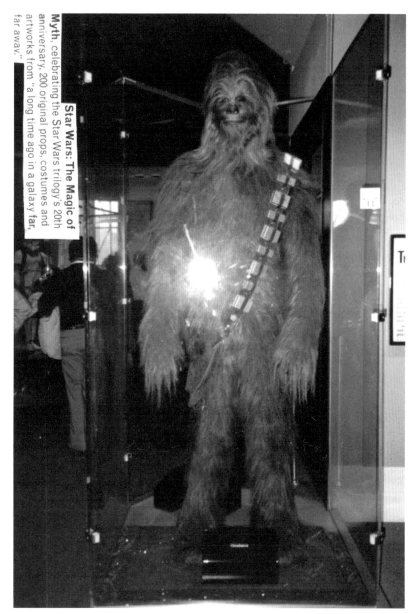

Star Wars: The Magic of Myth, celebrating the Star Wars trilogy's 20th anniversary, 200 original props, costumes and artworks from "a long time ago in a galaxy far, far away."

Fig. 1 (left): Ticket stub to the Star Wars 20th anniversary exhibition in the National Air and Space Museum, Washington, D.C.

Fig. 2 (above): Life-size Chewbacca in a display case – Star Wars 20th anniversary exhibition in the National Air and Space Museum, Washington, D.C.

Introduction
Mika Elovaara

Star Wars communities is no different, but in the course of time, the saga has shifted to include more female characters, including female Jedi, and consequently, women have made their presence clearer and become a more vocal voice in critical response, online communities and related product consumption.

In Chapter 7, Zachary Ingle presents an examination and discussion of the philosophical and religious significance of *Star Wars* to fans worldwide. Based on his extensive research into the topic, Ingle begins with the appropriate acknowledgement of the work covered in *Star Wars and Philosophy*, stating that the contributors to *Star Wars and Philosophy* note the varying philosophies exhibited in the stories and characters within the *Star Wars* universe, from existentialism and dualism to Zen Buddhism and bioethics, among others. However, Ingle's primary focus is on explaining and discussing how the concept of the Force seems to be the most significant philosophical or religious contribution of *Star Wars* to its fans around the world.

In Chapter 8, Kris Jacobs takes us into the language(s) of *Star Wars* through a variety of angles, from actual phrases that have become part of languages worldwide to a linguistic exploration of the various languages within the films, and a look into the communicative power of non-verbal expression, growls, beeps and whistles by the characters in *Star Wars* films – all of which holistically work to constitute, perhaps unexpectedly, a language of its own, one that is understood both in a galaxy far, far away and in every corner or Planet Earth.

In Chapter 9, Brendan Cook guides us through various examples to illustrate how *Star Wars* 'has captured the hearts, minds and imaginations of millions and millions of fans, and their children and grandchildren in the last four decades'. Cook's anecdotes, statistics and recounted milestones of the saga work to lay the foundation for his conclusion that 'the world was irrevocably changed in May of 1977', and that 'it is highly unlikely that the impact of the saga launched that fateful summer will end with this generation of fans'.

In Chapter 10, Neil Matthiessen presents his study of the marketing of *Star Wars* and how it has impacted the legacy and continuing popularity of the saga. In Matthiessen's words, *Star Wars* has survived and continued to grow for 35 years 'due to the careful planning and new marketing strategies along with embracing its fans'. Through his explication of the history of the franchise, Matthiessen explains us the success of the 'modern twentieth/twenty-first century mythology and a brand that has generated over 20 billion dollars in revenue'.

Concluding the book, Jason Davis and Larry Pakowski's Chapter 11 discusses the influence of *Star Wars* to the global culture holistically. According to the authors, *Star Wars* 'has morphed into something much more tangible, something much more *real*' (than 'just' films). It has burgeoned into a phenomenon that wields influence over fans in their daily lives and dominates pop culture, and is clearly evident in our society and global culture as a whole. And it is for this reason that we are writing this book. Indeed,

as Davis and Pakowski conclude, '*Star Wars* has infiltrated our daily lives and is ever present'. Counting on that everlasting 'ever-presence', Disney recently bought the Star Wars franchise from Lucas with a reported $4 billion price tag. Among the immediate consequences of the business transaction are Episode 7 (scheduled for theatrical release in 2015) and planned spin-offs focusing on specific fan-favourite characters, such as Han Solo and Boba Fett.

With over 30 years of global popularity and more stories to come, Star Wars continues to be current and relevant. Whether it is the children who were born after *The Revenge of the Sith* (Lucas, 2005) was released who wear *Star Wars* clothing before their parents have allowed them to watch any of the films, the female fans who grew up wanting to become Mara Jade, the male fans between seven and seventy who still enjoy watching *A New Hope* (Lucas, 1977), or the female students in my *Star Wars – A Complete Saga?* class who took it so they would understand their husbands and brothers better, the saga that George Lucas created does, indeed, affect our lives almost daily, whether we ourselves are fans of the saga or not. And that, dear reader, is the true phenomenon of *Star Wars*. ●

Chapter
1

Star Wars as a Character-Oriented Franchise

Jason Scott

→ The *Star Wars* trilogies are reputedly the most successful film franchise in history. However, the films are only the beginning of the story from a long time ago, in a galaxy far, far away; the character-oriented franchise *Star Wars* developed through merchandising, transmedia branding and cross-media storytelling. George Lucas, and his company Lucasfilm, achieved phenomenal box-office success with the films, but also initiated groundbreaking retail sales of an array of branded toys, comics, books, and other licensed and media products.

This commercial success was nurtured by their continuing appeal to both a broad range of consumers and also the enduring interest of fans, involved in patterns of repeat consumption. The spin-off extensions of *Star Wars* into new stories and media formats have been sustained by these same engaged fans. Comic books, novels and video games have allowed fans to extend their experience of the films, the Expanded Universe and its characters. Beyond this commodification, exploiting people's fascination with all things *Star Wars*, the fans themselves have also contributed to *Star Wars*, not simply as consumers but participating in creating and producing the *Star Wars* culture.

This chapter thus seeks to explain the complex relationship between the films and other authorized versions of *Star Wars*, and their emotional resonance and social use by fans, the foundation of which is the saga's character-orinetedness. Whilst Lucasfilm continue to develop and promote numerous lines of *Star Wars* product, fans repurpose these, creating their community through 'the different ways in which people engage with *Star Wars*, the role it has in their lives, and their relationship to it', noted by Will Brooker in his book *Using the Force*. This results in a fine balance, a tension, between the demands of brand management, merchandising and intellectual property control, on the one hand, and the freedom of participation, communal interpretation and ownership on the other. This is epitomized in the complementary ways *Star Wars* characters continue to be used, by both Lucas and the fans, as heroes and villains, mythic archetypes, icons, identities and objects of affection.

We will return to explore the various fan activities that encompass *Star Wars* characters, whether encouraged or supported by the official fan clubs and Lucasfilm websites or practiced more independently later in this chapter, but let us begin by considering how *Star Wars* consolidated a brand, what we might now call a transmedia franchise. In the creation, development and re-releasing of *Star Wars*, Lucas and his team adopted certain strategies which determined its status as a character-oriented franchise. Some of these approaches were already established in Hollywood, while other aspects were more pioneering. However, the ability of *Star Wars*, and its characters, to infiltrate the public consciousness, and be widely appropriated, was also dependent on the groundswell of affection with which audiences embraced the first film, and the ways this initial word-of-mouth excitement and attachment was maintained and developed by fans, providing the basis for their ongoing engagement. Several critics at the time of the release of *Star Wars: A New Hope* (Lucas, 1977) suggested what was distinctive about the film warranted this devoted response. A.D. Murphy, the *Variety* reviewer describing the film's 'movie magic', suggested that 'one identifies with the characters' and accepts their world, a distinction which arguably underpins much fan engagement with *Star Wars*. The critic Roger Ebert similarly praised the film's magic, distinguishing the film's involving narrative, with characters 'so strongly and simply drawn [...] to identify with'. This echoed the production notes, in which George Lucas stated that casting for the film was focused on making the characters 'believable to an audience [so] that they

Star Wars as a Character-Oriented Franchise
Jason Scott

identify with [them]'.

Still, in the twenty-first century, *Star Wars* exemplifies a character-oriented franchise facilitated by interlinked media and ancillary products based around pre-sold or familiar proprietary characters. This resulted from organizing the films around a group of distinctive characters, and foregrounding them in all advertising, as well as dispersing these same characters through other stories and non-narrative forms. The release of a comic book and novelization before the first film served to introduce the characters and story, while early promotion and the marketing of the film around an ensemble of characters, rather than star actors, has been replicated for each re-release and sequel. Posters, trailers, comics and books of the films, and subsequently action figures (and their packaging), and a range of merchandise, functioned to consolidate the recognition of iconic characters. Unlike most blockbusters of the time, *Star Wars* was not sold on the basis of star actors. Instead, the trailers and posters relegated the star Alec Guinness (and Peter Cushing) to the periphery. Thus, George Lucas and Lucasfilm imitated the serials such as *Flash Gordon* (1954–55) that provided some of his inspiration, as well as film series, in developing proprietary characters. Rick Altman, in his book *Film/Genre* notes that Hollywood had consistently developed 'idiosyncratic and easily identifiable characters', in some cases adapted from other media such as comic strips and books, radio serials and pulp fiction, to provide the basis of series, sequels and remakes, 'so that each individual film could contribute to marketing the next'. Series of B movies were defined by their characters. According to Michael Allen in his book *Contemporary US Cinema*, Lucas adopted this customary practice, using *Star Wars* to create what Altman calls 'a brand-name-like feature', a brand embodied in the range of characters, to ensure audience appeal for subsequent films, but also readily adapted into toys and other merchandise, with 'the possibilities of replicating images and characters' built into the film. Lucasfilm also imitated Disney, which from its beginnings had 'created strong brands or characters [...] [marketed] through films and merchandise', as noted by Janet Wasko. First with Mickey Mouse, and then *Snow White* (Cottrell and Hand, 1937), Disney exploited the widespread recognition of something magical in each of these, with toys, comics, and even branded foodstuffs. Lucasfilm similarly embraced Disney's careful control of intellectual property to exploit characters, images, and stories through licensing, developing trademarked characters and titles within films, and for cross-promotion, which contributed to a similar shift of emphasis more broadly in the New Hollywood. Now, with Disney's purchase of Lucasfilm and the rights to the Star Wars saga, the two franchises with a very strong character-oriented essence, are under the same umbrella.

As described in greater detail in various chapters in this book, *Star Wars* transcended the success of a blockbuster in giving rise to a series of films, but perhaps more significantly, generating phenomenal sales in comics, publishing, toys, reconfiguring the licensed toy and action figure markets, and subsequently video games. The accumu-

[handwritten margin note: How Disney and Lucasfilm work together. Character embodiment.]

lated global grosses for the films of $4 billion (given in 2008) pales in comparison to the $15 billion retail sales of merchandise. Toys contributed up to $9 billion, with 250 million units sold by Kenner between 1978 and 1985, and Hasbro *Star Wars* toys consistently placed as the number one boy toy in the United States, since the prequel films. Alongside these toys, books and video games constituted the core merchandise, with 72 million *Star Wars* books in print, including over 70 *New York Times* bestsellers, and *Star Wars* video games eclipsing all other movie-based franchises. Very few film franchises achieve recurrent bestsellers across this range of media and products, and only Disney consistently profits from merchandise and marketing tie-ins on this scale. Furthermore, George Lucas has famously secured greater royalties and percentages of the box-office revenues of the films – another parallel with Disney.

Moving beyond managing and policing the brand of *Star Wars*, Lucasfilm have furthermore developed close supervision of the authorized stories featuring the *Star Wars* universe and characters, to ensure continuity, and consistency with what is termed the '*Star Wars* canon'. Thus the integrity of the approved timeline of events, *Star Wars* characters and their actions is maintained. This is applied through the use of a series bible, providing authors and game creators with background information on the *Star Wars* characters and universe, but also monitored through Lucasfilm continuity and licensing coordinators. Whilst this has proven essential to the cross-media storytelling that has proliferated within the franchise, it also causes tensions with the fans of *Star Wars* who contest and debate their own elevated narratives and elements, defined as the 'fanon'. Chapter 4 in this book, 'Fans, fics & films… "Thank the maker(s)!"' discusses fanfilms and fiction in greater detail, but for the purposes of a discussion of the character-orientedness of *Star Wars*, a closer look at the role of fanfiction and the Expanded Universe as part of the fan phenomenon is called for.

Unlike with most films, where fans' desire to know or learn more about the characters and their 'lives' is never satisfied, *Star Wars* fans are encouraged to follow the 'life' of the *Star Wars* characters through their continuing adventures in books and comics, and transmedia storytelling coinciding with the films has introduced new characters or provided complementary backstory to inflect the film narratives. Peripheral characters, or those who died early in the films, such as Qui-Gon Jinn, Darth Maul, Jango Fett and Boba Fett, have been revisited, allowing fans to re-experience them, and extend their story backwards, or fill in gaps. Apart from the transmedia interquel project *Shadows of the Empire* (1996), which coordinated a novel, comics and a video game, Lucasfilm has predominantly limited extensions within the timescale of the films. Hence Lucasfilm, whether with comics, books or video games, has prompted expanding the saga through secondary characters, whose stories parallel the protagonists of the film, or extending *Star Wars* with second generation characters, whether the immediate descendents, following the events of *Return of the Jedi* (Marquand, 1983) or precursors. These narratives constitute the Expanded Universe or the EU. To know the whole *Star Wars* story, fans of

Star Wars as a Character-Oriented Franchise
Jason Scott

the EU are encouraged to buy all the books and/or comics. This builds upon the significance of the early comics, film novelizations and spin-off novels, but also the interest amongst fans of extending the stories of major *Star Wars* characters within their own fanfiction.

Preceding the EU, fanzines were commonly focused on fanfiction, poetry and fan-art, but they also included editorials and articles which encompassed fan speculation, debates and interpretations of the films, as well as forms of news and information, transcribing interviews, compiling reviews, and collecting biographical details about characters and the actors who played them. Much fanfiction concerned extending the stories, or as one fan noted in *Alderaan* issue 3, as early as September 1978, 'developing' the characters from the film. Henry Jenkins, in his article 'Quentin Tarantino's *Star Wars?*', notes that fans began writing 'original fiction based on the *Star Wars* characters' within months of the first film, due to the fans' impulse to 'create and recreate [...] characters over and over again', expanding them beyond the 'single life of their original creation'. Commonly, this involved providing backstories to characters, for instance Han Solo in *Falcon's Flight* from 1978, Luke Skywalker, Princess Leia, and Darth Vader background stories within *Jundland Wastes 2* (1981). Fanfiction in fanzines also placed the characters in different situations, and relationships to each other, defined as 'alternative universe' stories in the Fan Fiction archive hosted by TheForce.Net, with generic variations stressing romantic or sexual relationships, or strong emotions, such as angst, between characters. The broad spectrum of fan stories, these reworkings of the characters from the films, is judged by fidelity to these characters, whether they remain 'in character', and whether original characters created by fans are consistent, or idealized 'Mary Sue' personalities, a term derived from *Star Trek* fandom. Fanzines also included ongoing discussion about fans' right to rework or transform the characterization of canonical characters from the films, which was at odds with Lucasfilm's policing of copyright, and the official Lucasfilm Fan Club. Whilst this tension existed during the 1980s and early 1990s, Lucasfilm more widely intervened with cease and desist notices to fan websites in the late 1990s, and has continued to do so whenever fan writers have attempted to use commercial means to distribute their work. This ran parallel to their attempts to co-opt or regulate forms of fanfiction – for instance whilst authorizing fanfilms with Atom-Films, films limited to parodies and documentaries, fan home pages hosted by starwars. com enabled Lucasfilm to assert their authority over fan-produced material.

Brooker, in his article on 'Internet Fandom' has suggested the centrality within *Star Wars* fandom revolves around the fans' 'emotional investment in the continuing lives of the protagonists'. Fans are distinguished by the range of their ongoing responses to characters, including recurrent consumption of character texts, but also their interpretations and speculations about characters, their value judgements and distinctions, or participatory modes of extending characters themselves in fanfiction, art, fanfilms, cosplay and digital forms. Several accounts of *Star Wars* fandom suggest that the fans'

continuing imaginative bonds with the characters, or their immersion in the EU, differentiates them from the general audience. Whilst some of these activities are elicited by Lucasfilm's transmedia storytelling, or encouraged by the official fan clubs and websites, core fandom can be distinguished by more autonomous activities. Fanzines and fan-produced websites stress fan selection, interaction and editorial control, but have diminished access to authorized material, cultivating the fans' sense of community and ownership of *Star Wars*. The fans' distinctive interests, values and ways of reading *Star Wars* negotiate the commodity elements of the franchise to stress their discerning taste and critical awareness, which is in contrast to Lucasfilm's dissemination of authorized information, often promoting consumption.

The fans' sense of ownership of *Star Wars* derives from their repeat viewing and imaginative engagement with memorable scenes, dialogue and characters, as well as other materials such as trailers, interviews, books, comics, and other forms of cross-media storytelling. Taken together, this enables their collective discussion of *Star Wars*, with distinct ways of understanding the films and characters, encompassing speculation and their exhaustive familiarity with the minutiae of characters. Whilst fans debate their interpretations, and hierarchies between films, scenes, and favourite characters, these disputes are premised upon their shared specialist knowledge, and the accumulative but always unfinished project to fully comprehend the saga and their object of affection.

Since before the first film, fans have speculated upon the significance of characters and scenes to the continuing narrative, dwelling on individual words of dialogue, description from the crawl that opens each film, glimpsed characters or events in trailers or publicity stills, or the extract from the 'Journal of the Whills' that introduces the *Star Wars* novelization. For instance, conjecture about the identity of 'The Other' – another person with whom 'The Force is strong' – followed the release of *The Empire Strikes Back* (Kershner, 1980), epitomized by fanzine discussion in successive issues of *Jundland Wastes* through 1981 and 1982. Seemingly every possible 'other' – Leia, Wedge Antilles, Vader, Boba Fett, Lando Calrissian and Han – was evaluated and deliberated. Developing scenarios that resolve such enigmas has also inspired much fanfiction. Similarly, the announcement of each film's title, part of Lucasfilm's regulated release of information, has generated both guesses at the likely names and hypotheses about the clues they offer to the film's narrative, and importance of characters. This constitutes one aspect of anticipation that sustains fans between every new film or book, the long wait for the prequels or even the DVD release, evidenced by the Internet fed frenzy in the case of *Star Wars Episode I: The Phantom Menace* (Lucas, 1999).

The attention to the intricacies of individual characters, set against the overarching saga or *Star Wars* universe, is supported by transmedia narrative as *Star Wars* characters are developed across appearances in films and other forms, and derived from fans' multiple viewings, repeated close reading, and ongoing chat that builds shared

Star Wars as a Character-Oriented Franchise
Jason Scott

Fig. 1: The character-orientedness of Star Wars leads to a variety of ways of displaying fan favorites. (Image of Hannah King courtesy of Tracy King)

understanding of characters. Fans are distinguished by a concern with the seemingly trivial, incredibly detailed knowledge developed collaboratively in fanzines, news groups, message boards and fan websites. Nathan Hunt, in his discussion of 'The Importance of Trivia' argues this shared level of familiarity enables fans to recognize each other, like members of a family, to demonstrate their claim to ownership of the films they know about, and defines them as 'discerning [and] rational' in producing *Star Wars* culture. Yet familiarity is also modulated to articulate humour, shared emotional attachments, and applied to evaluation of fan productions and performances of character identities. Communal distinctions, producing and archiving specialist knowledge also frame the ongoing debates about the significance of characters, interpretations, and determining hierarchies and the canon or fanon within *Star Wars*.

Much due to their strong attachment to their beloved characters, fans have immersed themselves in an enduring but continually developing process of debate, critically assessing each film, usually against the original film and its agreed value, or evaluating the merits of characters. From early disputes in early articles and letters pages within the fanzines *Alderaan*, *Southern Enclave* and *Jundland Wastes* over the relative strengths of Leia, Ben Kenobi, or particularly Luke and Han, to divisions over *The Empire Strikes Back* and *Return of the Jedi* (especially the Ewoks), these differences of opinion mark the work involved in making sense of the shared object of affection. It animates the community and enables individual fans to articulate their emotional response to the characters. This is exemplified by the distinct readings developed by fans between the trilogies of films, grounded in repeat viewings, and ongoing reflection which has often emphasized seemingly marginal characters from the films. Some of the more extensive include elevating Wedge Antilles, with the Cult of Wedge consolidated within the online mailing list alt.fan.wedge from Dec 1993, or the pivotal role of Boba Fett, also affirmed by the prevalence of websites devoted to him by the mid-1990s. In the early 1990s, the Internet newsgroup rec.arts.sf.starwars.misc (RASSM) featured reinterpretations of the Original Trilogy, deifying the 'Gonk' power droid or promoting the character Lobot. These discussions exceeded debate, embodying the ways *Star Wars* fans acted out their affiliation to elements of the *Star Wars* saga or universe, for instance Imperialists or Jedi, and produced self-conscious and collaborative stories about *Star Wars* and its meanings in which the fans became participants.

Within the revived official fan club and magazines, and the websites, fans have advanced various characters from the films (and the actors who played them) or Expanded Universe, and redefined their *Star Wars*. Will Brooker, in his book *Using the Force* and articles, has comprehensively discussed the controversies amongst fans about Lucas' authorship and what constitutes the canon, particularly marking issues of the fans'

Weakness ←

Strength
↓
fan led
franchise

ownership in relation to the Special Editions (and other versions) of the Original Trilogy. More markedly, when *The Phantom Menace* failed to fulfil fan expectations, this divided fans with a significant number of fans rejecting aspects of the film. Consistent with the saga's character-orientedness, the character of Jar Jar Binks was widely criticized and even rejected in the global fan community. This reversed the practice of valorising characters by dedicating Internet home pages to them, compiling and sharing news, information and speculation like fanzines to open up discussion and develop communal celebration of characters, and *Star Wars* more generally. With sites like www. jarjarbinksmustdie.com, and others listed by The Jar Jar Hate Newsletter, fans demonstrated their dislike of this character through fanart and postings, identifying him with Lucasfilm's merchandising. This critical perspective, described as 'anti-fans' by Jonathan Gray, nonetheless maintained similar fan distinctions and practices, including fan productions such as the bootleg DVD *The Phantom Edit* that removed the character from the film. However, more commonly, *Star Wars* fans continued to applaud the saga, with these 'gushers' regaining prominence after *Attack of the Clones* (Lucas, 2002).

Since the infant years of the franchise, *Star Wars* fans have consistently gathered together, within fan clubs, through fanzines, mailing lists, online forums, and more literally at conventions with events like the *Star Wars* Celebrations and *Star Wars* Weekends. These real world assemblies draw fans together to meet friends and the stars and creative personnel behind the characters and films, demonstrating the community's collective appreciation for the saga and its characters. Forms of fan production and performance also feature fans wearing the costumes, but also performing the identities of characters. Cosplay is one instance of fans engaging with *Star Wars* 'in character'. Costumers such as the 501st Garrison aim for screen accurate portrayals to bring canonical *Star Wars* characters to life, and are even memorialized in Trading Cards. Online simulations involve fans acting out *Star Wars* storylines and scenarios, immersed in character; whilst fans also adopt character when contributing to collaborative stories such as those on RASSM. Although this varies from the emphasis upon strict fidelity, as with fans self-creating avatars in massively multiplayer online role-playing games (MMORPGs) such as *Star Wars Galaxies* and *The Old Republic*, consistency with canon characters facilitates immersion in the *Star Wars* universe. Across all these performative modes of fandom, fan's play *Star Wars* characters, often blending into everyday life, where fans repeat or repurpose *Star Wars* character dialogue, or imitate character speech acts when posting on forums. These boundaries are further blurred in the case of *Pulp Fiction* (Tarantino, 1994) re-scripted for *Star Wars* characters, on RASSM, which bears similarities with the action figure film *Quentin Tarantino's Star Wars* discussed by Henry Jenkins; *Pulp Fiction* re-scripted for *Star Wars* similarly affectionately pastiches the *Star Wars* characters and memorable scenes. In all these instances, the fans' continuing affection for the characters, their emotional investment in what happens to them in films, cross-media storytelling and fan-produced extensions, their shared fascination

Star Wars **as a Character-Oriented Franchise**
Jason Scott

alongside debates provides the social glue for *Star Wars* fandom. Whilst Lucasfilm suc-
ceeded in developing a brand and franchise residing in its trademarked characters, fans
have nonetheless made them their own, continuing to find meaning, pleasure, humour,
and a shared sense of that galaxy far, far away in the heroes, villains, creatures and droids
of *Star Wars.* ●

GO FURTHER

Books

Star Wars
Will Brooker
(London: BFI, 2009)

Contemporary US Cinema
Michael Allen
(Harlow: Longman, 2002)

Using the Force: Creativity, Community, and Star Wars fans
Will Brooker
(New York & London: Continuum, 2002)

Film/Genre
Rick Altman
(London: British Film Institute, 1999)

Extracts/Essays/Articles

'The importance of trivia:
ownership, exclusion and authority in science fiction fandom'
Nathan Hunt
In Mark Jancovich, Antonio Lazaro Reboll, Julian Stringer and Andy Willis (eds).
Defining Cult Movies: The cultural politics of oppositional taste
(Manchester: Manchester University Press, 2003), pp. 185–201.

'Quentin Tarantino's *Star Wars*?
Digital cinema, media convergence, and participatory culture'
Henry Jenkins
In David Thorburn and Henry Jenkins (eds).
Rethinking Media Change: The Aesthetics of Transition
(Cambridge, MA: The MIT Press, 2003), pp. 281–314'.The magical-market world of
Disney'
Janet Wasko
In *Monthly Review* (vol. 52, no. 11), April 2001, pp. 56–71.

'Internet Fandom and the continuing narratives of *Star Wars, Blade Runner* and *Alien*'
Will Brooker
In Annette Kuhn (ed.). *Alien Zone II: the spaces of science-fiction cinema*
(London: Verso, 1999), pp. 50–72.

Chapter
2

Fashion from a Galaxy Far, Far Away

Jonathan DeRosa

→ So there I was, standing in line, surrounded by a Sith Lord, a space rebel and a slave girl. I know this sounds like the set-up to some bad joke but it's true. And to be honest, I felt a little underdressed rocking some cargo shorts, an Avengers T-shirt and a Red Sox cap. I had this notion that the people were judging me more for not being a part of their universe. But I guess that's what happens when you venture out on the annual Comic Book Day and engulf yourself with the likes of *Star Wars* and comic book fans. Heck, even my girlfriend was smart about the situation; she wore her red Calvin and Hobbes as Han Solo and Chewbacca shirt.

Fig. 1: A clever Calvin and
Hobbes take on Chewie
and Han. © Chris Wahl

This makes a lot of sense.

So what is it about this 30-year-old movie that made the likes of my girlfriend and these nerd-tastic cosplayers let loose by adorning their favourite Jedi or space rebel apparel?

As I waited in line to obtain my free comics, I passed the time ogling over these characters – particularly slave Leia, much to my girlfriend's dismay – that had come to life in the middle of a parking lot on a hot spring day. I wondered what it is about *Star Wars* that still offers such a profound impact on today's society that we make the conscious decision to spend money to sport our love for some galaxy far, far away. Especially when *The Avengers* (Whedon, 2012) had just been released a day before, shouldn't I see more Iron Mans, Captain Americas, Hulks, and Thors, maybe even a Black Widow?

It's then I realized that there's no difference between my decision to put on an 'Avengers' T-shirt versus someone dawning red and black make-up, some spikes and a double lightsaber to become Darth Maul. Okay, well there's a bit of a difference; prep time, devotion, and overall nerd confidence, but still, what matters is the heart that we are all showing.

From the beginning, *Star Wars* was a cultural revolution for a plethora of reasons. No one had seen a blockbuster like that before with its characters, effects, crazy space mobiles, lightsaber duels and, yes, a whacky fashion sense. Probably to the surprise of the saga's creator, George Lucas, as well as the global film audiences, in an era of flaired hair, bell-bottom pants and Woodstock hippies, *Star Wars* changed the way people dressed themselves forever. When you look at it more closely, each character in the saga, already in the Original Trilogy (OT), has their own individual style. For example, in *A New Hope* (Lucas, 1977), Obi-Wan Kenobi is like a desert monk with his brown hood that covers his entire body, in *Empire Strikes Back* (Kershner, 1980), Lando Calrissian is essentially Shaft in space, and in *The Phantom Menace* (Lucas, 1999), Princess Amidala often looks like a geisha with her bright red dress and mime face paint. Every main character in the saga has their own attitude and their looks reflect that. Consequently, due to the strong character-focus of the saga, fans who passionately relate to their favourite characters also adopt their looks, for various purposes, as described in Chapter 2.

One must wonder how crazy must studio executives have thought George Lucas was when he pitched the idea of samurai-like warriors duelling it out in space. We do know that Lucas was turned down by studios before 20th Century Fox nodded 'yes', and without a successful precedent for Lucas's concept, who can blame those executives? Besides the challenges for special effects and a narrative about a 'space odyssey', this

Fashion from a Galaxy Far, Far Away
Jonathan DeRosa

film relied heavily on characters. And what kind of characters exactly? Luke Skywalker wore a white tae kwon do outfit as he traversed Tatooine looking for droids (Aunt Beru must have had to wash that outfit *constantly*). Skywalker changed it up each go around. In *Empire Strikes Back*, Luke wore a very fetching snow jacket, complete with a dapper hat and scarf combo that kept him warm and ready in case a Wampa attacked. In the trilogy's finale, Skywalker adorned an all black outfit to represent his inner struggle between the Force and his father. Luke's outfit in *Return of the Jedi* (Marquand, 1983) heralded more towards the dark colours of the Emperor and Vader than the previous movies. Speaking of the dark giant, Darth Vader was like Frankenstein in space; humongous, all black, and overtly menacing with his flowing cape, colourfully-buttoned chest, and frightening helmet head. Audiences had never seen a creation like Vader before. As soon as he blasted through the bay doors in *A New Hope* he encapsulated the world/galaxy with terror and sheer wonderment – all through his appearance. Now if that's not a fashion statement, I don't know what is!

Popular entertainment magazine, *Empire*, recently compiled a list of 'The 100 Greatest Movie Characters' and Vader landed himself on the second slot of that list (behind Tyler Durden from *Fight Club* [Fincher, 1999]... I know, right?). But aside from the fact that Vader would own everyone in an underground fight club, *Empire* had the following to say about the man in black:

To hell with the Emperor – he wasn't even around for most of the action. Darth Vader is, to every child of *Star Wars*, the supreme badass in the galaxy. He is everything that scares you as a child, cutting a huge, imposing figure, wearing doom-laden black, and breathing through some kind of ominous respirator – surely enough to give any person in their formative years the willies. The masterstroke behind Vader's design is that mask. The cold, expressionless cover is difficult to read, and makes for a much scarier experience than a human face can give.

And what was his finest hour? 'His entrance,' said the magazine.

Darth Vader's costume is so iconic that when I met the actor who embodied the infamous Jedi, David Prowse (my first celebrity meet ever), I was let down that he was just a regular tall man (and had a German accent).

When discussing fashion inspired by the first episode of the saga, we must not forget the crowning achievement of fashion in the *Star Wars* universe: Princess Leia in *A New Hope*. To make this tough space princess stand out from her unrevealing white gown, George Lucas and the creators gave Leia two cinnamon buns for hair on each side of actress Carrie Fisher's head. This allowed Leia to stand out as an icon as she stood her ground with the boys whilst they traversed the galaxy. You can't dress up as Leia without those buns in your hair, ladies.

Well, I may be getting ahead of myself. You *can* dress like Leia without buns if you

Fig. 2: Run, here comes the fashion icon of the century!

want to get a little bit skimpier. A friend of mine, a fellow life-long *Star Wars* enthusiast, once stated that 'slave Leia is every man's fantasy in the history of forever'. Such an exaggerated statement has more than a grain of truth in it, at least when it comes to those who love *Star Wars*. Leia's slave outfit must have blown men's minds back in the 1980s, probably some females' too. While people walked out of *The Empire Strikes Back* saying, 'Man, I cannot believe that Darth Vader is Luke Skywalker's father', a lot of men must have come out of *Return of the Jedi* saying 'I cannot wait to see that again and again and again'. They may have given each other a chest bump or two as well. What makes this even more culturally incredible is that after all these years, this kind of outfit can make men physically shrug off their girlfriends to check out another woman dressed in a slave Leia costume. Men, surely, cannot be proud of themselves at that moment, but that's exactly my point; men are slaves to the slave outfit. And whether we like it or not, it goes a long way in considering the fashion influence of the *Star Wars* saga. It is because of such reactions, mostly by men, that the slave outfit remains popular among women, not just for Halloween but for other occasions of dress-up as well, as further illustrated in the discussion of *Star Wars* and gender in Chapter 6.

Okay, enough about Princess Leia and all her gloriousness; I want to play a game with you. When one talks about fashion in a movie about space pirates and mystic knights, you would think that the costumes would be tough and/or classy, like James Bond's classic suit in any of the films, Peter Fonda's black American jacket in *Easy Rider* (Hopper, 1969), right? Onto the game, I'll describe an outfit and you try to guess who it belongs to. Our example sports feathered hair with a tight, low-cut, buttoned-down white shirt that exposes his chest hair, covered by a black leather vest and tight black pants, which are strapped securely by two belts, one with a large silver medallion on its front, tucked into knee high boots.

Who am I? If you said a member of the Village People, you're wrong (and no *Star Wars* fan likes you). I'm Han Solo, one of the most manly, iconic male figures in bad-assery of all time. I shoot first and don't even ask questions later because who needs to when you've got Jabba the Hutt breathing down your neck? Men of all ages want to be me, not only because my best friend is a seven-foot Wookie, or I get to fly the Millennium Falcon, a ship that made the Kessel Run in less than twelve parsecs (*Star Wars* nerds, please stand up), while seducing intergalactic princesses, it's because I look good doing it. Looking back 30 years ago, Harrison Ford's depiction of the space cowboy was probably a big reason why *Star Wars* had a strong female demographic from the very beginning.

Trust me. I was Solo for Halloween one year and my girlfriend couldn't keep her hands off me, and she was born in 1988, eleven years after the original film's release. She wasn't around when *Star Wars* came out, yet the man still has swagger to this day! Along with Indiana Jones, Harrison Ford has got this male icon thing on lock!

So my girlfriend and I were born well after the original *Star Wars* release, yet we still get giddy when we see some sweet T-shirt with R2-D2 on it, or the one I just purchased

Fashion from a Galaxy Far, Far Away
Jonathan DeRosa

today – a mash up of *Star Wars* and *The Good, The Bad, and the Ugly* (Leone, 1966), entitled 'The Good, The Bad, and The Wookie'. And how reflective of *Star Wars* fashion is this example? It goes to show that fans' affection with all things *Star Wars* is not limited to character costumes.

Star Wars has such a current effect on *Star Wars* fashion that an article pops up concurrently regardless of any official release dates for *Star Wars* products or films. Most recently, I came across an article entitled 'Her Universe Star Wars Spring/Summer Apparel Line to Debut at Disney's Star Wars Weekends and Online'. The article, written for Albany, New York's *Times Union*, details a brand new fashion line called Her Universe that's strictly for females, created by actress Ashley Eckstein, the voice of *Star Wars: The Clone Wars* (2008) character, Ahsoka Tano. Some of the clothing from Her Universe includes 'a racer back tank top and fashion tops featuring such beloved characters as Princess Leia, R2-D2 and Darth Vader as well as a unique Princess Leia zip-hoodie and a fun Ahsoka Tano youth tunic created to help young girls feel just like Anakin's Padawan learner on 'The Clone Wars'". Also included in the line-up are a good luck charm given to Padme by a young Anakin in *The Phantom Menace*, canvas bags with various *Star Wars* symbols on each, and, of course, a Jedi onesie for toddlers.

The various individual examples of *Star Wars* fashion beyond character dress-up or cosplay demonstrate one key fact about the significance of *Star Wars* fashion: you name it, it's available: earrings, necklaces, wallets, hats, watches, anything that isn't a thimble, you can bet there's a *Star Wars* related image on it. People on websites like Etsy, where crafty artists can sell their homemade goods online, sell *Star Wars*-themed merchandise. Simply typing in the movie title on the site's search engine brings up a plethora of space goodies that includes a chef's apron, a variety of dresses, bathing suits, gloves, shoes, shirts of Darth Vader riding a bike or Stormtroopers as the 'American Gothic' painting, a pillow (for your cat), and a rubber R2-D2 bodysuit that gives slave Leia a run for her money.

Let's now take a look at what goes beyond the fashion that people can take on or off – the franchise fashion extends to realms far farther away than one might think. What about those who decide they love their Boba Fetts or their Jabba the Hutts *so* much they want these individuals tattooed on their body forever? Globally, tattoos are becoming more popular every day. It's almost gotten to the point where you're in the minority if you are between 18 and 40 and you don't have one; it almost works as if there were inadvertent peer pressure to head to the tattoo parlour and get the classic 'Mom in a heart' just to fit in.

'If you're trying to fit the entire Original Trilogy on your arm, it's probably not going to happen,' says Wilmington, North Carolina bartender Roger Harris, as he rolls up his sleeve, exposing his arm of tattoos. 'I love *Star Wars*. I may not love every character but I love what it means to me. And that meaning is what I wanted tattooed on my body. Bam, the Millennium Falcon!' He points to the Millennium Falcon that hovers below his

Fig.3: like band t-shirts, Star Wars t-shirts are fashionable around the world.

Fig.4: Another clever Star Wars-themed take on another product of Popular Culture. © Adam Works

bicep, right next to Boba Fett's sneaky ship, the Slave 1. 'It incorporates Han Solo and Chewbacca in one image. It's a space saver '. And there it is. Wearing T-shirts or dressing up in *Star Wars* fashion isn't enough for some people. Some people want the ink of these beloved intergalactic characters forever embedded onto their bodies. Harris concludes, 'I am not done, either. This is just the beginning '. And what is fashion, really? Does it end with what we wear or what tattoos we adorn ourselves with? In my book, I declaratively say no. I can decorate my laptop, car, and notebook with *Star Wars* stickers, my backpack with patches, my room with action figures, my walls with posters, my shelves with books and, of course, movies, and so on. All of this extension of personal fashion is simply a means of expressing one's love for personal passions/hobbies, in this case a distant galaxy that remains far, far away. It's to simply let others know I'm in on the joke, if you will. It's a nonverbal form of communication to others that says whether or not you are into this world, we have something to talk about.

I cannot tell you how many times in the past week since owning a hat that has the Captain America shield on it, strangers, mostly older males, surprisingly, have come up to me and declared, 'Man I love your hat!' Each time I'm taken aback by these strangers' willingness to approach a stranger and engage in their personal nerdy love for the Sentinel of Liberty. By wearing this cap (pun intended) that displays the logo of a fictional superhero who represents the good of the American dream, it communicates to others that I'm just as knowledgeable and passionate about this subject as they are. Wearing this particular hat says, 'Hey I'm proud of my comic book knowledge. We all should be. Come talk to me. We're not so different, you and I'. And it's even more interesting because it is men commenting on each other's appearance, something that despite living in the metrosexual early twenty-first century, is still not as much a standard as it is unconventional behaviour.

The reason I purchased the Captain America hat has everything to do with the fashion choice I was making. I bought it because too many people were coming up to me when I was wearing my Boston Red Sox hat. Strangers would come up to me at the bar or a restaurant, complaining about the latest game or how much they hated the team and/or me and I should take it off. Whoa! Slow down there! I just liked the Red Sox hat because it fit my head well, not because I was passionate about the Red Sox. I know, I know, it's a sin! It wasn't until I realized that wearing this hat did not communicate to strangers, 'Hey, this hat is comfortable'. I was being dishonourable to other fans of the Boston team. It's like I was wearing the letters of a fraternity that I had not pledged. Boston, I'm sorry! Now, please stop throwing things at me as I walk down the street.

Fashion from a Galaxy Far, Far Away
Jonathan DeRosa

This same sentiment goes for anyone who's wearing a Rebel logo on his or her hat/shirt/apron/shoes/whatever and does not know what it means. I consider them a fraud for not knowing the difference between a Rancor and a scruffy-looking nerf herder! I, myself, was a fraud for wearing a pair of red socks on my hat and not knowing the intimate details of the Red Sox or baseball, in general (you score field goals in baseball, right?) My fashion had betrayed me so I had to correct it to join the right team once again. I had a choice, just like Luke, to pick the right side. Instead of America's game, I went with America's superhero. Hence, the Captain America hat.

So as I stand next to a mixture of adults playing dress up, from Dr. Octopus to Darth Maul, I realize something about these fashion statements. I wear my 'Avengers' shirt because the movie made me feel like a kid again – rummaging through comics to find out about my favourite superheroes and blasting my way across backyards pretending I was the Amazing Spider-Man trying to play fight with my friends who were Wolverine, a Teenage Mutant Ninja Turtle, or anyone from the pages of the comics we spent time reading instead of doing homework. Dressing up in *Star Wars* outfits can certainly look ridiculous to outsiders who aren't down with the Fett, or don't know the difference between a moon and a space station, but what these fanboys and fangirls are really saying is 'This is who I am. This world is a part of me'. By the way I dress, I identify with myself and with others by how this movie phenomenon changed my life.

Star Wars gives its fans a sense of sheer wonderment, an imaginary escape from the humdrum toils of everyday life. Just because I met Darth Maul in the parking lot of a comic book store on a Saturday doesn't mean he has to put on a suit and tie Monday and deposit my checks or balance my finances. But I tell you what, if I got the chance to sit down and talk about who the real Darth Maul is, you can bet your bottom dollar it would not be the suit-and-tie Maul, it'd be the dual-lightsaber-wielding Sith lord who took the time to take off that tie to get his costume just right. The Darth Maul who fake fought with Dr. Octopus, fake kidnapped slave Leia, and took photos with the starstruck children, who in all respects, should be way too young to even know about *Star Wars* considering its original release date, calling out, 'Darth Maul, Darth Maul! Will you take a picture with me?' That is the real Darth Maul. That is the real man behind the outfit; the man who takes his fashion sense seriously enough to say I love that galaxy far, far away. This is who I am. ●

~~~~~~~~~~

**GO FURTHER**

**Extracts/Essays/Articles**

'Her Universe Star Wars Spring/Summer Apparel Line to Debut at Disney's Stars Wars Weekends and Online'
In *Times Union*, 15 May 2012,
Available at: http://www.timesunion.com/business/press-releases/article/Her-Universe-Star-Wars-Spring-Summer-Apparel-Line-3559765.php

**Websites**

'*Empire* Online', www.empireonline.com

Picture link:
Calvin and Hobbes:
http://www.forevergeek.com/wp-content/media/2010/08/chewieandhan.jpg

Chapter
3

# Fans, Fics & Films...
# 'Thank the Maker(s)!'

Marc Joly-Corcoran and Sarah Ludlow

→ Since 1977, *Star Wars* merchandise has been a staple fan favourite. For over three decades, George Lucas has taken full advantage of this fact: whether it is toys, computer games, television programmes or novels, fans of all ages and levels of enthusiasm are willing to invest time and money into owning and experiencing their own portion of Lucas' creations. For some fans, however, the desire to be involved with Star Wars goes beyond the official merchandise and TV spin-offs.

The one part of his creation which Lucas has been unable to fully control is how his films have been used since their release, inspiring, as they have, thousands of fans to create their own extensions to his carefully crafted designs.

Fan activities are prolific the world over. This chapter aims to portray the differing levels of fannish involvement within two of the most inspired and inspiring fan mediums available: fanfiction and fanfilms. According to Csikszentmihalyi's theory of 'optimal experience', '[...] creativity results from the interaction of a system composed of three elements: a culture that contains symbolic rules, a person who brings novelty into the symbolic domain, and a field of experts who recognize and validate the innovation'. These elements are all found within the *Star Wars* fandom, where experts are free to be fans and fans can become experts in their chosen medium; the viewers find pleasure in both viewing and creating within the *Star Wars* universe.

### Fanfiction: the new fannish rebellion?

Fanfiction can be loosely defined as 'a derivative work' – a text based on a canon source, which is expanded upon, developed and reimagined by fans. This can include fictions based on television programmes, novels, films, comics or opera; any base text which lends itself to further development by a reader/viewer. The term 'derivative work' is utilized again and again within fanfic circles, and is well known, as A.T. Lee shows in the online essay, 'Copyright 101: A Brief Introduction to Copyright for Fan Fiction Authors'. Writers use this legal loophole in copyright laws to legitimize their repeated use of protected works, much to the continued dismay of canon authors, and specifically, with regards to our area of interest, George Lucas.

The modern version of fanfiction (fics, hereafter) is recognized as having developed from the television programme *Star Trek* (1966–69), from which a paper-based fanzine was created by fans in order to extend the universe seen on-screen. As Camille Bacon-Smith documents in her book, *Enterprising Women: Television, Fandom and the Creation of Popular Myth*, these 'zines, as they were known, were circulated by a small group of fans and swapped, borrowed or bought at fan conventions, which then led to the development of mailing lists and 'zines being posted across country, and later, across continents. As time passed and the possibilities provided by the emerging Internet became apparent, paper-based 'zines began to disappear, making way for instantly accessible, online fics, as well as communities that did not need to rely on long distance phone calls or snail mail to communicate. Since the mid-1990s, the growth of online fanfiction sites has boomed, and a current search on the Internet for the term 'fan fiction site' returns over 33 million hits.

### Fighting against the Lucasfilm empire

Upon its release in 1977, the *Star Wars* universe became an instant fan favourite, its cult status since bolstered by sequels and novels, comics and CGI children's programmes,

Fans, Fics & Films... 'Thank the Maker(S)!'
Marc Joly-Corcoran and Sarah Ludlow

Fig.1: One of a number of 'cease-
and-desist' letters from Maureen
Garrett to publishers of Star Wars
fanzines, sent in 1981, stipulating
the terms of fic content. Other ex-
amples can be found at Fanlore.org.

action figures and cartoons. Moreover, for the past 35 years, Lucas
has continuously changed and amended the original films, ruled
over the direction and plots developed in the Expanded Universe,
and created spin-off programmes which further explore the fic-
tional universe that he created. With these continued renewals
and reboots to his creation, it is therefore understandable that
Lucasfilm and the affiliated Official Star Wars Fan Club took a dim
view of the fanzines which began to appear almost immediately
after *A New Hope* (Lucas, 1977) was released; Lucas' ultimate crea-
tive control began to falter, falling – or rather being determinedly
taken – into the hands of the fans.

According to the Fanlore website, documented under the
heading: 'Open Letter to Star Wars Zine Publishers by Maureen
Garrett', in 1981, a series of letters were exchanged between Mau-
reen Garrett, director of the fan club, and the publishers of multi-
ple 'zines, requesting that any stories, if they were to be created and distributed by fans,
were to adhere to Lucasfilm standards. Specifically, this set of letters referred to fics
with pornographic or overly violent storylines. This was likely brought into focus when
the fic 'Slow Boat to Bespin', featuring a sex scene between Han Solo and Princess Leia
was published, allegedly to the horror of George Lucas. That Lucasfilm did not pursue
legal action was more likely due to the costs outweighing the results, yet the situation
emphasized the overarching issues of copyright and prompted a reaction from Lucas-
film. The underlying stipulations were made clear via a letter from Howard Roffman of
the Associate General Counsel to 'zine publishers stating that:

[...] a great deal of the infringing material published in small circulation fan publications
has been overlooked by Lucasfilm because the costs of stopping such activities are of-
ten out of proportion to the amounts involved. This situation is tolerable to Lucasfilm
only so long as the materials published are not harmful to the spirit of the Star Wars
saga. The publication of 'Slow Boat to Bespin' and the threat of publishing similar arti-
cles has caused us to re-evaluate our policy, and I can assure you that it will no longer be
safe for publishers such as you to feel immune from enforcement action by Lucasfilm.

No legal action was ever taken by Lucasfilm with regards to fic writers, yet these
sternly worded messages appear to have affected the development of the fandom in
a unique way. Lucas is openly aware of fics and 'zines, and allows them to be published
without legal recourse, whilst fans take clear steps to adhere (in the majority) to the
standards requested in the 1981 letters. Whereas some authors – such as Anne Rice and
Robin Hobb – have openly rejected fics based on their works, and still others, like J.K.
Rowling, wholeheartedly support it, Lucas remains tentatively balanced between en-

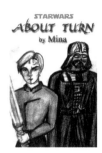

*Fig.2: Cover art for
'About Turn', by Mina.*

couraging the fan dedication perpetuated within fic communities, and maintaining creative control of his works. Perhaps because of this, his presence seems to linger within *Star Wars* fics more than any other authors' or directors' in theirs, and as we will see in the following section, compromises are made on both sides in order to allow fans the opportunity to create, whilst simultaneously reinforcing Lucas as the final authority on all things *Star Wars*.

### Fanfiction: the *playful* side of the Force

By moving the Star Wars characters and settings beyond the canon films, fans are able to duplicate the almost 'paranoid mist' Elizabeth Evans has recognized in her book *Transmedia Television: Audiences, New Media and Daily Life*, when fiction merges with reality, and a source text becomes important enough to an individual to matter *outside* its original medium. Crafting a new set of stories, or developing films based on the source text, become ways of creating and controlling a canon without having to follow the plotlines set by the original creator. In an attempt to portray the attraction of fanfiction to *Star Wars* fans even now, 35 years since its initial release date, let's look at an example from a popular online archive created specifically for *Star Wars* fics, The Force. net. Mina's 'About Turn', archived in January 2002, ranks at the top of the site's 'most hits' list. The fic is considered well-received, with over 80 positive reviews, 207 ratings, and an average score of 9.71/10 across those ratings.

It is important to note from the outset that 'About Turn' is a true example of the balance between fan and Lucasfilm. The 'notes' section posted before the story remarks that 'the author wishes it to be known that the following is an edited version of the original story. The changes were made to meet the guidelines established by TheForce.Net'. As a *Star Wars*-specific archive, TheForce.net has stipulated that those requests made by Lucasfilm in 1981 be adhered to, meaning that Mina's fic – whilst existing in its full form on alternative archives – is edited here, in respect of Lucas' wishes. This highlights the constant tension between the pleasure of partaking in fannish behaviour and the acknowledgement of the original creator as benevolently tolerant; Star Wars fans alternate between adoring Lucas and despising him, but the respect for his wishes is necessarily recognized among the fic writing community, compelling ficcers to abide by certain boundaries, or be forced to post their fics outside the more specialist archives.

That being said, the text in 'About Turn' itself utilizes a commonplace trope within fic writing, the 'AU', or alternate universe, and stretches the limits of believability when compared to Lucas' canon. This subcategory encapsulates the promise of Elizabeth Evans' 'delicious otherness'; here, fic writers can immerse themselves in characters not only different from themselves, but in the *possibilities* that Lucas chose not to follow.

In Mina's AU, after the unfortunate incident at Bespin where Luke Skywalker learns of his parentage and loses a hand in a lightsaber battle with Darth Vader, Mina has the distraught and injured protagonist rescued by his friends, only for his genealogy to be

**Fans, Fics & Films... 'Thank the Maker(S)!'**
Marc Joly-Corcoran and Sarah Ludlow

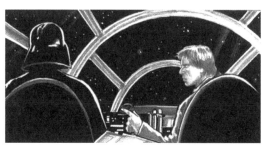

discovered by his former comrades in the Alliance. From this point onwards, Mina retells the canon plot of the original three films with Luke being chased out of the Alliance, taken in by Palpatine, and Darth Vader/Anakin Skywalker turning to Leia in order to track down and aid his missing son. At this point, the summary alone sounds ludicrous to any-one, fan or otherwise, who has seen the canon films. Yet Mina's fic emphasizes the *play* element integral to fan productions, as the audience becomes participatory, as Jenkins' *Textual Poachers* suggests, by crafting stories beyond the canon texts. Fic writers find it fun to experiment with canon characters, to test the boundaries of their personalities and see how far into AU it is possible to go without losing the original sense of wonder that *Star Wars* evoked.

In another example from 'About Turn', as jarring as the above image may be at first, the interplay between Han Solo and Vader/Anakin creates a fully realized scene; the dialogue is believable, the characters recognizable. Small touches like, for example, the fact that Anakin admits to having built 'Threepio' previously in both the canon time-line and the AU version tie together both canon and fanon, and help solidify this playful creation as equally enjoyable to the original.

Paraphrasing Csikszentmihalyi, Evans states that the act of creation ensures that a fan's 'attention to a particular activity is so intense that the reader becomes immersed in it completely, ultimately feeling "a sense of exhilaration, a deep sense of enjoyment that is long cherished and that becomes a landmark in memory for what life should be like"'. This level of immersion is clearly not the same amongst all fans, but the theory remains sound. The fact that Mina's fic is almost 58,000 words long denotes the dedi-cation involved in creating fics, but such commitment would be unsustainable without the pleasure of the creative process supporting the fic writer's endeavours. When the pleasure/interest wanes, so does the amount of fic created. Writing fics enables a fan to 'immerse' his or herself in their chosen canon, yet allows them the opportunity to explore the depth of and often further the existence of fictional characters. The hope of continuing the initial viewing pleasure, of revisiting the 'cinephanic' response that the original viewing produced, ensures that fic writing is not only a source of repeated enjoyment by both writer and reader alike, but that the canon material is also perpetu-ated by the act. If nothing else, George Lucas can take comfort in the fact that, although ficcers are continually utilizing his intellectual property for their own pleasure, they are likewise continually creating new possible realities within the Star Wars universe, ex-panding and solidifying an ever-growing, ever-loyal fanbase with each new text.

———

*Fig.3 (above): Luke tempted by the Dark Side. Original artwork by Rachelle Porter, created for and posted along-side 'About Turn'.*

———

*Fig.4 (top): Darth Vader meets his future son-in-law. Original artwork by Rachelle Porter, created for and posted alongside 'About Turn'.*

### Fanfilms : directed by fans?

Clive Young, the author of *Homemade Hollywood – Fans Behind the Camera*, proposed the following definition of a fanfilm: 'An unauthorized amateur or semi-pro film, based on pop culture characters or situations, created for non-commercial viewing'. This is the definition which we adhere to throughout this chapter. As we examine what it takes

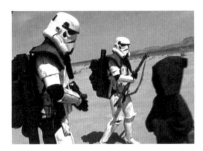 

Fig.5 (far left): TROOPS (1997) dir. Kevin Rubio

Fig.6 (left): George Lucas in Love (1999) dir. Joe Nussbaum

to *be* a fanfilm director, we can identify specific types of fanfilm director, each stemming from different interests and level of emotional engagement.

Making a *Star Wars* (*SW*, hereafter) fanfilm may be, for many young directors, an excuse to recreate a lightsaber duel in a forest, whilst others might seriously intend to expand the *SW* universe. In either case, directing a fanfilm is the perfect way to showcase artistic abilities. However, do directors have to be *SW* fans to direct *SW* fanfilms? This is not a discussion about the definition of the word fan, an issue already approached by Matt Hills, Henry Jenkins and many other scholars, but rather an inquiry as to the necessity of a fanfilm creator having to be specifically a fan of *SW* itself. To answer the question as best we can, we interviewed some of the most popular *SW* fanfilm directors about how they view their own fannish status.

### Fanfilms and their directors

Directed by Kevin Rubio, *TROOPS* (1997) is probably the most well-known *SW* fanfilm. The film is a spoof, parodying *SW* and the American television show *Cops*. Using a shaky, documentary camera style, the story follows a squad of Stormtroopers looking for stolen robots on Tatooine – to fans, an obvious reference to C-3PO and R2-D2 in *A New Hope*. But Rubio doesn't consider his film a fanfilm: 'The term "fanfilm" did not exist when I made my short, so I do not consider it as such'. Regardless of what Rubio may think about the status of his film, according to the definition given by Clive Young, Rubio's *TROOPS* does fall into that category. Rubio even received the attention of Lucas himself, as Jenkins says in his book *Convergence Culture*: 'Lucas admired the film so much that he gave Rubio a job writing for the Star Wars comic books'. This leads us to wonder if Rubio made *TROOPS* simply out of love for the saga, as an emotionally engaged fan might do, or because he wanted a 'calling-card' in order to showcase his talents as a director. When questioned, Rubio responded bluntly: 'I wanted to get work as a director and writer. It says so right in the credits'. He admits that he was not overly inspired by the saga when he was young, yet the first trilogy was nevertheless a turning point in his career choices: 'I was not really inspired by "the *Star Wars* Universe", but the films [...] made me want to become a film-maker'.

*George Lucas in Love* (1999), directed by Joe Nussbaum, is another well-known *SW* fanfilm. Nussbaum's short comedy tells the fictional story of the young Lucas during his graduate years, and how he had the inspirations for creating such unique characters. As the camera roams the campus, Lucas passes nearby people who bear close resemblance to Chewbacca, Han Solo, C-3PO, R2-D2, and an enigmatic teacher speaking in a cryptic way, much like Yoda. Nussbaum saw Rubio's *TROOPS*, and then *Shakespeare in Love* (Madden, 1998). The idea came to Nussbaum and one of his friends to spoof the two. The idea of using George Lucas was not immediate, but, according to Nussbaum, it ended up working: 'We were both *SW* fans, and it seemed like the perfect idea, especially with Episode I coming out in a few months'. But Nussbaum also had a specific

Fans, Fics & Films... 'Thank the Maker(S)!'
Marc Joly-Corcoran and Sarah Ludlow

*Fig. 7:*
*Quentin Tarantino's Star Wars*
*(1998), dir. Evan Mather*

objective: 'The motivation for making *GLiL* was quite simple; I wanted to showcase my ability to direct a movie in order to get jobs as a mainstream director'. Yet the stigma of being a 'fan' remained an issue, fan media having previously been seen as something 'lesser', something amateur and therefore inferior. Nussbaum explains how he felt after reading an article in a newspaper just before the shooting of *George Lucas in Love*:

The *Los Angeles Times* did a big article about *SW* fanfilms [...]. It made me feel like every twenty-something wannabe film-maker in the country had already made a *SW* spoof in their basement for around $100 and here I was, a huge idiot who was about to spend $25,000 to do the same thing. I almost called off the shoot!

Another fanfilm director, Evan Mather, used *SW* action figures to create stop-motion animations. Like a patchwork, his fanfilms are filled with references to classic movies, cut with audio clips from the saga. Jenkins even titled a chapter of his book *Convergence Culture* after one of Mather's fanfilms, *Quentin Tarantino's Star Wars* and stated that: 'No digital filmmaker has pushed the aesthetic of action figure cinema as far as Evan Mather. Mather's films, such as *Godzilla versus Disco Lando*, *Kung Fu Kenobi's Big Adventure*, and *Quentin Tarantino's Star Wars* represent a no-holds-barred romp through contemporary popular culture'. Again, when asked, Mather's main motivation was clear: 'To have George Lucas see them and hire me to work on the prequel trilogy'. Unfortunately, this did not happen, but it did not slow his enthusiasm for the saga.

*Fig. 8:*
*Ryan VS Dorkman (2003),*
*dir. Ryan Wieber and*
*Michael Scott*

Other popular fanfilms include *The Formula* (2002), directed by Chris Hanel, and *Ryan VS Dorkman* (2003), directed by Ryan Wieber and Michael Scott. In the latter, the narration serves only one purpose: to show a spectacular, tightly choreographed, lightsaber duel, which drew a lot of attention and praise from the fan community. But, like Rubio, Wieber states that: 'I don't technically even consider my films "fanfilms" as they only ambiguously take place in the *Star Wars* universe; at best, they are just lightsaber fights'. Indeed, the protagonists don't wear Jedi robes, but plain T-shirts and pants! However, they still make use of one of the most iconic *Star Wars* creations – the lightsaber – alongside their infamous sound effects. Furthermore, as these young directors don't own the copyrights to use the 'ambiguous' weapons for commercial purposes, Young's definition can still be applied.

There remains another category of fanfilms that openly intends to contribute to the *SW* universe, including fanfilms such as *Star War: Revelation* (2005), *Knight Quest*

(2001), and *Broken Allegiance* (2002). However, parodies and mockumentaries are openly encouraged by Lucasfilm, so long as they do not make serious (as opposed to humorous) changes in the canon narrative. As for their fannish status, Nick Hallam, director of *Broken Allegiance*, was already working as a freelance director when he produced his film. Even though admitting that '*B.A.* certainly helped showcase [his] talents as a film-maker' it was not his primary objective. When questioned, he stated '[He] had no agenda beyond making a good short film and expressing [his] appreciation for *Star Wars*'.

### Fanfilm directors: a typology

Whilst this discussion of *SW* fanfilms has been necessarily brief, it has been useful in order to highlight three specific types of fanfilm directors.

Type 1: the fan who wants to relive what we call a 'cinephany' (for example, Mather). Marc Joly-Corcoran coined the term 'cinephany' in his research to evoke the feeling of having experienced a 'certain' form of revelation whilst watching a movie. The idea can be likened to filmic epiphany, televisual epiphany, etc. Joly-Corcoran defines 'cinephany' as follows: 'The sensory and/or intellectual awakening [...] that creates a positive affective attunement when the viewer is specifically experiencing a fictional audiovisual production [...]'.

Type 2: the pragmatic fan who wants to showcase his talents, using borrowed characters and universes from popular culture, in order to get a job in the entertainment industry (Rubio, Nussbaum and Wieber).

Type 3: the fan who just wants to make a fanfilm for the sake of the experience alone. The third type serves to distinguish the pragmatic fan (Type 2) from the 'enthusiast' fan (Type 3) who does not specifically, and primarily, intend to showcase his artistic abilities (Hallam).

As we have seen, being a *SW* fan is not a pre-requisite in order to direct a *SW* fanfilm. However, these categories are not exclusive either. For example, with the exception of Hallam, all of the fanfilm directors interviewed in this chapter belong, according to this typology, to Type 2, but could also belong to the first or third type at the same time.

The narrative within the fanfilm *The Formula* can be used as an example to illustrate Type 1 and 3. During a scene, the protagonist is excited by holding a lightsaber. In this obvious parallel, fanfilm creation allows fans to reactualize their first affective experience, the cinephany. However, the protagonist's friend is enthused at the prospect of making a fanfilm. It is not the cinephany which thrills him, although he does mention the word epiphany: 'Our man Tom has had an epiphany, a vision, a task to take us from our mundane lives and give us something more productive to do'. He is excited by the making of a product – the fanfilm – rather than the cinephanic responses it may evoke. This practical approach links back to Csikszentmihalyi's 'optimal experience': '[...] people who are strongly engaged in an activity for its own sake; what they experience is so

*Fig. 9: (Type 1)*
*The Formula (2002),*
*dir. Chris Hanel.*
*Fan film director.*

enjoyable and intense that they want to relive it at all cost and for the sake of the activity alone'.

## Conclusion

Whilst we can trace fan activities back hundreds of years, to even Greek mythology, there is one thing that makes all the difference to fan activities in our modern age: the Internet. According to Jenkins, this is what makes fan culture more visible than ever: 'The Web provides a powerful new distribution channel for amateur cultural production'. Later in his text, he emphasizes the importance of the sharing/communal possibilities within fan culture: 'To create is much more fun and meaningful if you can share what you can create with others'. This is certainly true of fanfiction, as with a worldwide stage upon which to publish, comes a worldwide readership. The same can be said of fanfilms. However, whereas it is impossible to assess if the activity of writing fanfictions might have had any professional impact on the writers themselves, largely due to the necessarily pseudonymous nature of fic writing, the experience of making a fanfilm has enabled individuals to achieve a career in the entertainment industry. Almost every film director interviewed for this piece has either succeeded in acquiring employment (Wieber, Hanel), or was already a professional working in the industry (Rubio, Nussbaum, Hallam).

*Fig. 10: (Type 3)*
*The Formula (2002),*
*dir. Chris Hanel.*
*Fan film director.*

Whether professionally accomplished or not, it is doubtless that fan media producers have been profoundly affected by the fictional universe offered by *SW*. Passionate fans or otherwise, *SW* continues to allow and inspire individuals to create, play and communicate with complete strangers, joined only by a single point of commonality: a galaxy far, far away... ●

## GO FURTHER

### Books

*Transmedia Television: Audiences, New Media and Daily Life*
Elizabeth Evans
(Oxon: Routledge, 2011)

*Homemade Hollywood, Fans Behind the Camera*
Clive Young
(New York: Continuum, 2008)

*Convergence Culture, Where Old and New Media Collide*
Henry Jenkins
(New York: New York University Press, 2006)

*Vivre, la psychologie du bonheur*
Mihaly Csikszentmihaly
 (Robert Lafond: Paris, 2004 [1990/91])

*Fan Cultures*
Matt Hills
(New York: Routledge, 2002)

*Enterprising Women: Television Fandom and the Creation of Popular Myth*
Camille Bacon-Smith
(Philadelphia: University of Pennsylvania Press, 1992)

*Textual Poachers: Television Fans and Participatory Culture*
Henry Jenkins
(London: Routledge, 1992)

*Flow: The Psychology of Optimal Experience*
Mihaly Csikszentmihalyi
(New York: Harper Collins, 1991)

**Extracts/Essays/Articles**

'Copyright 101: A brief introduction to copyright for fan fiction authors'
A. T. Lee At 'Whoosh', http://www.whoosh.org/issue25/lee1.html.

"Original Cinephany and Reappropriation: The Original Affect and its Reactualisation
through Emerging Digital Technologies", Marc Joly-Corcoran
In Anna Maj and Daniel Riha (eds). *Digital Memories: Exploring Critical Issues*
(Oxford: Inter-Disciplinary Press, 2009), pp. 143–50.

Chapter
4

# Immersive and Interactive Adaptations and Extensions of *Star Wars*

Jason Scott

→ The interactive and immersive forms of *Star Wars* have developed within arcade, console and computer games, and later flourished and transformed with the growth of the Internet and other new media forms and technologies. With PC and video game adaptations of the *Star Wars* movies, and games with narratives or situations that intersect or extend the storylines of the films, fans and gamers use these games to immerse themselves in the *Star Wars* universe.

Fans of the *Star Wars* saga and gamers have embraced many of the *Star Wars* games, continuing to recall them nostalgically, but they have also rejected games that either disrupt their immersion with poor gameplay, attach the iconography or look of *Star Wars* to the surface of an established video game format, or present unfaithful adaptations to 'their' *Star Wars* universe.

In the 35-year history of the franchise, LucasArts, the computer and video gaming division of George Lucas's Lucasfilm (originally named Lucasfilm Games), has not only developed games that appear to be within this universe, they have also created games that rework, continue or expand the stories of *Star Wars* films, comics and books of the Expanded Universe, as well as to the fanfiction and fanfilms discussed in Chapter 4. Since the beginning, LucasArts has emphasized the narratives and narrative fit of their games, and develop the distinctions between types of adaptation and other cross-media storytelling evidenced within the *Star Wars* interactive games. Games have provided fans with evoked narratives, procedural adaptations, which offer an experience like that of the movie characters, or have resonated with the film narratives despite variations, such as the cross-over franchising of the Lego *Star Wars* games. Furthermore, they have also allowed *Star Wars* fans to experience unfolding *Star Wars* stories alongside their fellow fans. Addressing the prevalence of *Star Wars* games, and the ways both fans and LucasArts or the production companies have expanded these online, this chapter also provides a snapshot of the broader (massive) presence of *Star Wars* on the Internet. Developing *Star Wars* gamer communities and an infrastructure across websites to enhance their immersion and experience of the games, these fans and gamers have mirrored the use of the web and other digital technologies to connect, interact, collaborate and above all, play *Star Wars*.

Since first appearing on the Atari 2600 VCS, with *Star Wars: The Empire Strikes Back* (Parker Bros, 1982), *Star Wars* has proliferated across all the major computer and video game platforms, continuing with new mobile formats, online games and MMORPGs (Massively Multiplayer Online Role-Playing Games). *Star Wars* has been repurposed for each new technology, frequently as a flagship title to help sell hardware. In 2006, *Star Wars* was ranked fourth amongst all games franchises in the United States for video game sales for the main formats which dominate the industry, the pre-eminent movie-based Intellectual Property. LucasArts already trumpeted *Star Wars* as the most successful film-based license in interactive entertainment. During the 1990s, games based on the *Star Wars* saga accumulated more than $450 million in sales, followed by increased numbers of releases, but with less consistent successes as they migrated to the new generation of consoles to accompany the prequel trilogy. Since 2005, after the films, interactive gaming became a key means for Lucasfilm to grow and develop the *Star Wars* brand, resulting in their strategic shift to pay closer attention to projects that maintained the integrity and continuity of the *Star Wars* universe, but also diverging between titles aimed at casual gamers and children, and those targeted at *Star Wars*

Immersive and Interactive Adaptations and
Extensions of *Star Wars*
Jason Scott

gamers. Hence the Lego *Star Wars* games have achieved sales of 21 million units. LucasArts has also developed more challenging games, blending role-playing and combat to appeal to the core demographic for the games industry. Although this has resulted in a withdrawal from more niche gamer genres with Real Time Strategy, or even their origins in space and flight simulation games, gamers have sustained these games and genres themselves within their own 'modding' (modifying) community.

Since its inception, LucasArts has become more reliant on its *Star Wars* games and other licensed properties, but is distinguished further by its 'trademark storytelling'. As the company's vision suggests, each LucasArts release combines gameplay and advanced technologies with compelling storytelling, character development and vivid settings, foregrounding parallels with film. Even within their simulation games, LucasArts promoted a long tradition of highly acclaimed flight combat titles offering 'rich game play and a deeply engaging story'. The marketing as well as critical accounts of individual *Star Wars* games, whilst addressing other factors such as the rich or detailed environments, frequently valorised the compelling and engaging storylines, for instance the story of *Star Wars*: TIE Fighter (LucasArts, 1994, IBM/Mac), or the 'captivating nonlinear story line' of the video game adaptation of *Star Wars Episode I: The Phantom Menace* (LucasArts, 1999, PC/PlayStation). With its 'entirely original storyline', the game *Star Wars Knights of the Old Republic* (LucasArts/BioWare, 2003, Xbox/PC/Mac) was framed as a new chapter within *Star Wars*. Whilst this corresponds to Lucasfilm's projection of the *Star Wars* saga, rather than the brand, it also counters accounts by game theorists who identify narrative-based video games as marginal, and either less successful, or corresponding less to the specific strengths and capabilities of the video game medium. For instance, Jesper Juul, in his article 'Games Telling Stories?', describes the 'narrative frame' for an action game as 'something used for selling the game', not necessarily motivating completion of the game, and particularly contrasts the Atari arcade game *Star Wars* (1983) and its space simulation with the film's narrative. Although the producers of this game reworked a planned non- *Star Wars* game, *Warp Speed*, by transforming the ships and environment to match the Death Star attack and adding the voices of characters from the film, arguably, for many *Star Wars* gamers and fans, it constituted a defining experience of entering this part of the film's narrative and its universe.

Marie-Laure Ryan, in her book *Narrative Across Media* suggests narrative elements in digital games function 'to lure players into the game world'. LucasArts has attracted gamers to their *Star Wars* games partially on the basis of their stories, or how these provide a basis for player missions or quests. However, most of the significant successes amongst the *Star Wars* games from the 1990s onwards have not been based upon, or tied to, the narratives of the films. Unlike *Star Wars Episode III: Revenge of the Sith* (LucasArts/Ubisoft, 2005, PS2/Xbox/GBA/DS), and the Lego *Star Wars* games, bestselling LucasArts games built around an original story or spanning and expanding several

film stories include *Knights of the Old Republic*, *Star Wars: Battlefront* and its sequel *Battlefront II* (Pandemic Studios/LucasArts, 2004 and 2005, PS2/Xbox/PC) which together sold more than 10 million copies worldwide, and *Republic Commando* (LucasArts, 2005, PC/Xbox). These four games each placed in the top 10 Xbox Live games (for unique users) in 2009. Earlier PC bestsellers include *Rebel Assault* (LucasArts, 1993, PC/Mac/SegaCD/3DO), the *X-Wing* (LucasArts, 1993, PC/Mac) and *TIE Fighter* (LucasArts, 1994, PC/Mac) games, as well as *Dark Forces* (LucasArts, 1995, PC/Mac/PS), and the later *Jedi Knight II: Jedi Outcast* (LucasArts 2002, PC/Xbox/GC). More recently, *The Force Unleashed* (LucasArts, 2008, PS3/Xbox and LucasArts/Krome Studios, 2008, PS2/PSP/Wii) achieved the highest sales for a LucasArts *Star Wars* video game (around 6 million units). These key titles were acclaimed upon release by critics recalling classic *Star Wars* games, as space simulations, first-person shooters, squad-based shooters, and console role-playing games (RPGs). They also encompass recurrent elements within *Star Wars* games, the introductory crawl, the films' music and sound effects, space and flight simulation, particularly featuring the Death Star and Hoth battles, and in later games the option of lightsaber battles.

Although some video games, such as *Star Wars Episode III: Revenge of the Sith*, are 'based upon' the film narrative, they are marked by the constraints and redundancy of playing a film, with player choices limited to fit the causal logic, to progress to 'cut scenes' that mirror the film's. Meanwhile some events of the film that suit the game engine are expanded, with other events omitted due to limits upon the characters available to be played. Beyond this, games 'based upon' the film narrative also extend the narrative, with secondary quests. Similarly to the fan response to all products related to the saga, passionate gamers have frequently criticized the games that are based on the movies. At least parts of the criticism has then been extinguished by LucasArts developing games such as *Star Wars: Starfighter* (LucasArts, 2001, PS2/Xbox/PC) and its sequel, *Jedi Starfighter* (LucasArts, 2002, PS2/Xbox), which function as playable extensions of the films, with storylines dovetailing key events in *Star Wars Episode I: The Phantom Menace* (Lucas, 1999) and *Attack of the Clones* (Lucas, 2002) respectively. These games immerse the player within the richness of the *Star Wars* universe, but motivate their actions with meaningful contexts and emotional resonance derived but differentiated from the film narratives. Henry Jenkins, in his article 'Game design as narrative architecture', suggests the *Star Wars* games convey narrative experiences through details of the environment, providing gamers 'broadly defined goals or conflicts' as well as micronarratives to enter at 'the level of localized incidents'. Beyond their narrative contexts, then, they can be distinguished in terms of how effectively they immerse gamers in the universe, and the degree and kinds of interaction available to the players. The *Star Wars* arcade game, as an early instance, enabled players to feel immersed by evoking the narrative – albeit only the Death Star trench run, from the first film – but with very limited ability to deviate from a predetermined sequence of events, in what is known as

## Immersive and Interactive Adaptations and
## Extensions of *Star Wars*
Jason Scott

*Fig. 1:*
*Star Wars: Masters of*
*Teräs Käsi was released for*
*PlayStation in October 1997.*

a rail shooter, as well as featuring a lack of story characters and backstory beyond that prompted by the iconography. Similarly, *Star Wars: The Empire Strikes Back* was designed to provide fast paced and fun gameplay that evoked images from the movie, and both *Rebel Assault* and its sequel still curtailed the players' ability to explore the universe or pursue their own quests, but adapted iconic scenes from the films.

Literally expanding upon these games, a number of the most successful *Star Wars* titles are procedural adaptations defined by Matthew Weise and Henry Jenkins in their article 'Short controlled bursts: Affect and Aliens'. These provide the gamer a moment-to-moment experience, as well as choices and abilities that are like those of the movie characters. This can be considered kinesthetic fidelity, as they can move through the universe in ways that feel authentic, which results from the game-specific elements, including player activities, the interface, how they control their character, and the audiovisual representation of game space being consistent with the films. In particular, the genre of the game needs to be consistent with the films, both at the level of iconography and the format (such as first-person shooter or space simulation). Hence, this contrasts with games that simply frame elements of the movie narrative within the conventions of a particular video game genre, 'skinning' the look of a film but with the possibilities for the players dependent upon an existing game engine. Many of the games for minor formats, licensed games on mobile devices, flash games on the Internet, as well as some strategy games and race games, repurpose and limit *Star Wars* within game formats. *Star Wars: Masters of Teräs Käsi* (LucasArts, 1997, PS) is a notable instance that used the characters of *Star Wars* within a fighting game, transforming the combat to minimize lightsaber use. Critics, fans and gamers judged this inconsistent with the *Star Wars* saga. Such games were in stark contrast to the space simulation games, in which players adopt the roles of peripheral pilot characters involved in the familiar action of the films, offering gamers the everyday experience of a Rebel or Imperial with such intricacies as coordinating using sensors and cockpit views, balancing shields, recharging lasers and throttle control to eliminate targets – all motivated by compelling stories that underpinned the missions and therefore validated the game's storyline. Similarly adhering to an established game format, but distinguished as immersing *Star Wars* fans in their familiar universe, the *Battlefront* games have been embraced by fans, who accepted their promotional premise to re-live the epic *Star Wars* battles.

The fans' insistence on certain level of narrative authenticity has not gone unnoticed by Lucas and his game company, LucasArts; for example, in the game adaptation of *Revenge of the Sith* (Lucas, 2005), the game designers stressed fidelity of the movement of characters, including lightsaber combat. Similarly, LucasArts' promotional ma-

terial on the making of *The Force Unleashed* emphasized game physics underlying an authentic experience of the *Star Wars* universe. Whilst this arguably contributed to both games' global sales, such consistency wasn't the only means to create widely popular games. *Lego Star Wars: The Original Trilogy* (LucasArts/Traveller's Tales, 2006, Xbox/Xbox360/PS2/GC/PSP/DS/GBA/PC) and the earlier game rework each movie as a series of progressive quests, with problems to solve, and the conclusions to these relegated to cut scenes, but arguably retains most of the narrative events in the films, whilst transforming these to fit game format conventions, combined with Lego building and a pastiche on the familiar scenes. However, despite the success of the *Lego Star Wars*, the *Star Wars* gamers have maintained far more persistent involvement with those games that provide more faithful experiences of the universe and saga.

Continuing engagement with games that have been superseded by the standards of the industry evidences part of this continuing fandom, but it is the support infrastructures and levels of investment in the games that differentiate the *Star Wars* gamers from casual players. What started with the likes of *Star Wars* RPG and MUD (Multi-User-Dungeon) and user-extended MUSH (*Multi-User Shared Hallucination*) sites, developing networks through online news groups, such as alt.games.dark-forces and alt.games.tie-fighter, via message boards, has expanded to encompass a range of gamer activities, particularly with the growth of websites archiving and circulating advice on playing and 'modding' games, and hosting online discussions and forums. Gamers gather in communities to play ongoing campaigns of the *X-Wing*, *TIE Fighter*, *Dark Forces* and *Jedi Knight* games, and collaborate on 'mods' for their favourite games. Communal websites showcase and share their mods and work as hubs for fan media based on games, such as fanfiction and films video-capturing games. Console gamers often focus on the multiplayer games hosted online, such as the *Star Wars: Battlefront* games on the Xbox Live system, but use websites and forums to collect into gaming clans and to discuss their favourite games, often bemoaning the lack of sequels or the disruption of 'hackers' in live games with cheat codes derived from the game coding. *Star Wars* gamers also gather in communities based on playing out their saga within non-*Star Wars* MMORPGs, or to mod non-*Star Wars* games by skinning them to appear like their universe. In all these respects, *Star Wars* gamers challenge generalizations about game playing as an individualized activity, focused on beating the game, beyond frequently stressing Player versus Player experiences. Instead, their competition and collaboration, as well as more technically demanding production or maintenance of their games, facilitate developing a culture rooted in their shared affiliation with the *Star Wars* universe as it is realized in games.

Another way gamers demonstrate their investment in *Star Wars* gaming, and particularly their immersion in unfolding *Star Wars* stories is in MMORPGs, whether the authorized and heavily resourced *Star Wars Galaxies* (LucasArts/Sony Online Entertainment, 2003) and more recent *Star Wars The Old Republic* (LucasArts/BioWare, 2011)

## Immersive and Interactive Adaptations and
## Extensions of *Star Wars*
Jason Scott

*Fig. 2:*
*A promotional advert*
*from ign.com.*

or even *Clone Wars Adventures* (LucasArts/Sony Online Entertainment, 2010) [a Clone Wars virtual world primarily for children], or the fan produced *Star Wars Combine* and attempts to maintain an emulation of *Star Wars Galaxies*. These allow gamers to interact with hundreds of thousands of *Star Wars* fans/gamers in an environment that is described by Squire and Steinkuehler as both 'designed and emergent', combining those elements including the storylines created by the producers of the game, but also dependent on the participation of gamers in developing the world through their emergent play. The game designers involved the gamers in testing before *Star Wars Galaxies* was rolled out, building their sense of ownership and enabling the producers to attempt to satisfy their divergent expectations, particularly between role-players and hardcore 'levellers', those most concerned with progressing in the game. The online networks associated with these MMORPGs have developed out of this collaborative relationship, at least initially, with the official websites hosting fan forums and facilitating gamers to develop a community, as well as their own terminology to discuss the game 'in character' so as not to disrupt their immersion in the *Star Wars* universe. In the case of *Star Wars Galaxies*, role-player gamers who emphasize their participation in creating the rich quality of universe and stories that they want within the game world also establish autonomous websites to gather together likeminded fans. Thus, in reality, at least partially inadvertently, the game designers have developed an open-ended sandbox environment for the global gamer community.

Often inspired by both their strong affection to the stories and characters of the *Star Wars* saga and their disappointment with the official products of the franchise, gamers have created unexpected ways of participating in the game, such as coordinated online gatherings of players in Cantina Crawls, where they created live performances that were captured as machinima (animated films set in the game with roles taken by player avatars). Beyond paralleling the much broader development of *Star Wars* fanfilms circulated online, Henry Jenkins notes in 'So what happened to *Star Wars Galaxies*?' how these were also used to protest the imposed changes to the game, for instance in *Cantina Crawl XII*, as well as to articulate the experience of playing the game whilst contributing to the emergent story world. Gamers also recorded the final moments within *Star Wars Galaxies*, as it was shut down, contributing to the archive of footage of the game hosted online on sites such as Youtube and prompting nostalgic recollections. As noted, *Star Wars* games have also sought to maintain their own emergent virtual worlds, whether small-scale versions of *Star Wars Galaxies* using an emulator, or the *Star Wars Combine* developed by and for *Star Wars* fans, to provide a more imaginatively unbounded *Star Wars* universe. *The Old Republic*, developed by LucasArts and BioWare/Electronic Arts

and costing over \$150 million, attracted *Star Wars* fans and gamers most broadly, with 1.7 million active subscribers, from 2 million games sold, dwarfing the 255,000 estimated subscribers for *Star Wars Galaxies*. The numbers have since fallen despite widespread critical acclaim for the MMORPG. Emphasizing story-driven operations and missions, but involving groups of players gathered in guilds, *The Old Republic* developed these elements of story and setting from the critically and fan acclaimed *Knights of the Old Republic* role-playing game, to appeal to both console gamers and the disparate MMORPG players. However, postings on discussion forums suggest that as with its predecessor, some players object to the guided play and limitations upon their exploration of the environment, providing less of the sandbox and emergent possibility space than their fondly remembered *Star Wars Galaxies*.

Considering the history and development of the immersive and interactive adaptations and extensions of *Star Wars* holistically, digital media and particularly the Internet have transformed *Star Wars* fandom, allowing fans to connect and interact on a much larger scale, distributing authorized *Star Wars* material, but enabling fans' ease of archiving, collaboration and circulation in producing their own versions of their saga and universe. The *Star Wars* gamers, as well as the online games, epitomize the broader growth of interactive sites, encouraging play and immersion. Websites for games like *Jedi Knight II* were presented as in the game, with intelligence reports addressed to Mon Mothma. The official *Star Wars* website www.starwars.com, launched in November 1996, was one promotional site providing information about upcoming films and the saga more generally, but initially organized around exploring different planets within *Star Wars*, including introducing the new worlds in the prequels. As it grew to attract four million users a month, up to seven million during film releases, it emphasized trailers and behind-the-scenes footage with the teaser trailer for *The Phantom Menace* generating over 10 million downloads, and the full trailer downloaded by 35 million. Alongside commercial websites created by the licensees of *Star Wars* to draw fans, fan produced sites proliferated, catering for every niche within *Star Wars* fandom, and developing the enduring but massive presence on the web, allowing for different kinds of investment. Countdown sites anticipated the new films. Sites like TheForce.Net disseminated news and celebrated, debated, nostalgically recalled and speculated about *Star Wars*. But whether continuing the early role of e-mail lists and message boards to connect fans, expanding the audience for fanzines or enabling fans to produce and circulate their own *Star Wars* films, *Star Wars* gamers have participated in this range of online practices and expanded them. ●

Immersive and Interactive Adaptations and
Extensions of *Star Wars*
Jason Scott

~~~~~~~~~~~~

GO FURTHER

Books

Narrative Across Media: The Language of Storytelling
Marie-Laure Ryan
(Lincoln: University of Nebraska Press, 2004)

Extracts/Essays/Articles

'Short controlled bursts: Affect and Aliens'
Matthew Weise and Henry Jenkins
In *Cinema Journal* (vol. 48, no. 3), Spring 2009, pp. 111–16.

'Generating CyberCulture/s: The Case of *Star Wars Galaxies*'
Kurt D. Squire and Constance A. Steinkuehler
In Donna Gibbs and Kerri-Lee Krause (eds). *Cyberlines 2.0: Languages and cultures of the Internet*
(Albert Park, Australia: James Nicholas Publishers, 2006), pp. 177–98.

'So what happened to *Star Wars Galaxies*?'
Henry Jenkins
At 'Henry Jenkins.org', July 2006,
Available at: http://henryjenkins.org/2006/07/so_what_happened_to_star_wars.html

'Game design as narrative architecture'
Henry Jenkins
In Pat Harrington and Noah Frup-Waldrop (eds). *First Person*
(Cambridge: MIT Press, 2002), pp. 118–30.
Available at: http://web.mit.edu/cms/People/henry3/games&narrative.html

'Games Telling Stories? A Brief note on games and narratives'
Jesper Juul
In *Game Studies* (vol. 1, issue 1), July 2001,
Available at: http://www.gamestudies.org/0101/juul-gts/

I FIND YOUR
LACK OF FAITH
DISTURBING.

DARTH VADER
A NEW HOPE

Chapter
5

From Bikinis to Blasters: The Role of Gender in the *Star Wars* Community

Erika Travis

→ Although some may still consider *Star Wars*, as well as space fiction in general, the domain of male fans, the claim is becoming less and less convincing as female fans continue to express their presence in the *Star Wars* community. Major media outlets may still approach *Star Wars* fans as a 'boys club,' but online communities and *Star Wars* merchandise marketing departments are beginning to meet the demands of the female fanbase.

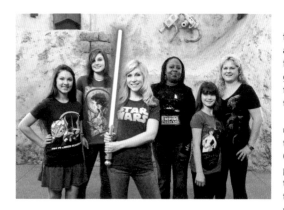

Fig. 1: 'Her Universe' helps make it 'Our Universe'.

Although tensions between varied interpretations of female characters and gender differences, perceived or actual, between fans still exist, the presence of female fans continues to grow across generations. Women and girls have found characters they appreciate and a world they love to live in, and they are not planning on relegating them to a single sex fandom any time soon.

Much of the critical analysis on the *Star Wars* films utilizes a mythological approach, confining its scope to the male hero quest, most famously explored in Joseph Campbell's *The Hero with a Thousand Faces*. This approach, unfortunately, often spends little time exploring the female characters within the films beyond their function within the hero's quest. What attention is given to female characters is generally confined to the female leads, Leia Organa and Padmé Amidala. However, this has not held true for fan analysis, as illustrated by numerous blogs and message boards exploring minor characters from the films as well as from the Expanded Universe.

As the first iconic *Star Wars* woman, Leia is far less criticized, by fans at least, than Padmé. Her character is credited by *USA Today*'s Lois Hatton with upending the traditional fairy trope of the damsel in distress, and Her Universe's little girls' T-shirt line promotes her as a 'self-rescuing princess'. This characterization certainly holds true for *A New Hope* (Lucas, 1977), in which she is an active force in the escape from the Death Star, as well as for *Empire Strikes Back* (Kershner, 1980), in which she stubbornly remains at her post in the rebel base while Imperial forces seize the structure. Lazypadawan of *Saga Journal* compares her to the archetypal woman warrior and historical figures such as Joan of Arc. She is smart, sassy, strong, and handy with a blaster all while maintaining her feminine appeal, and female fans have always seen her as a liberating force.

Most controversy over Leia's character revolves around the infamous metal bikini she wears as a slave in Jabba's palace. By far the most overtly sexual of Leia's costumes, the bikini has inspired disgust, lust (as Chapter 3 on *Star Wars* fashion also suggests), envy, and even its own fansite, 'Leia's Metal Bikini', which posts pictures of fans in their replica metal bikinis and organizes meet-ups at conventions. Its popularity as a costume has even inspired one of Nerd Machine's 'The More You Nerd' public service announcements, in which Kaley Cuoco jokingly encourages female fans to remember all of the other sexy cosplay options. Some critics view Leia's sexualized appearance and temporary enslavement as a devolution from her previous empowerment, but others, such as critic Diana Dominguez, see it as another reversal of a traditional trope, in which 'the powerless and sexually enslaved female uses the very elements of that enslavement to kill a captor that understood too late that he dangerously underestimated his prey'.

From Bikinis to Blasters:
The Role of Gender in the *Star Wars* Community
Erika Travis

Fig. 2:
Fangirl photographer/
blogger Savanna Kiefer
(www.plcohmy.com).

Metal bikini notwithstanding, female *Star Wars* fans generally hold Leia as the standard toward which all other female *Star Wars* characters must strive. She is smart and sexy, strong and compassionate, equally able to navigate the political arena or to engage in a shoot-out. She is able to do it all and have it all, as Dominguez notes, without being punished. It is often to her that Padmé Amidala is unfavourably compared. While some fan disappointment in Padmé may be attributed to nostalgia for the Original Trilogy and its characters, fan concerns, discussed in great depth on online message boards and blogs, go beyond the desire for a reincarnated Leia.

Like Leia, Padmé seems strongest in her first appearance, *The Phantom Menace* (Lucas, 1999). Like Leia, she is a political power, intent on safeguarding her people and her ideals. She asserts herself to the Jedi, the Senate and the Trade Federation, but shows humility in her dealings with the Gungans. She's not afraid to use a blaster and actively participate in the battle to free Naboo from the Trade Federation's droids. While some fans and critics may have been less than impressed by their introduction to Leia's mother, concerns become more apparent in *Attack of the Clones* (Lucas, 2002).

In *Attack of the Clones*, Padmé's appearance, like Leia's in *Return of the Jedi* (Marquand, 1983), takes a decidedly sexualized tone. She wears more sheer fabrics, bares her shoulders and midriff, and allows more of her hair down during her courtship with Anakin. Tricia, from 'FANgirl the Blog', finds the arena scenes where Padmé's midriff is bared unnecessary: 'Having the Nexu rip off the bottom half of the shirt to her diplomatic attire is simply gratuitous – it adds nothing to the story or to her characterization. Instead, it falls right into the typical pattern of marginalizing female characters by showing their skin'. This scene in *Attack of the Clones* eases the shift from the powerful Padmé of *Phantom Menace* to her dwindling role in *Revenge of the Sith* (Lucas, 2005).

As with Leia, Padmé comes under most scrutiny for her portrayal in the final instalment of her trilogy. Her pregnancy seems to restrict her from the political or physical action of the plot. Some fans see this as a natural outgrowth of her need to keep her pregnancy hidden and thus they accept it easily; others see it as a marginalization of this ultimately female experience. The most controversial moment of the film, however, is Padmé's death – a death which earned a spot in the science-fiction website 'io9' list of the '10 Most Undignified Deaths in Science Fiction and Fantasy'. Some, such as critic Diana Dominguez, attempt to explain the portrayal as a reflection of the challenges modern girls face, and others, such as Lady Aeryn of the online academic fan journal

Saga Journal, argue that she is the victim of a 'common fairy tale convention: a mother dying in childbirth'.

Others, as seen in a *Saga Journal* poll from 2006, see her death as linked with the symbolic death of Anakin, or a symbolic death of the Republic. While some fans accept and romanticize Padmé's death as a natural, tragic outlet of the star-crossed lover motif, others find it very disturbing, and online discussions regarding the incident are often lengthy and heated. Lex of 'FANgirl the Blog' condemns the scene as 'the single most damaging scene of all' to Padmé's character and many of his readers agree. On her Live-Journal message board, a fan identifying herself as chameleon_irony responds to fan outrage at Padmé's death:

I understand that female fans don't like this because, Padmé being the main female character in the prequels, they are impelled to identify with her, and a 'weak' woman who can get depressed, who has limits to what she can handle, isn't someone you normally want to identify with in fiction. One of the things that makes fiction enjoyable is fantasy – being able to 'insert' yourself into the story and imagine yourself having extraordinary adventures. It's similar when male fans get pissed off about male characters who are too flawed/'weak'/'wimpy'/just not perfectly 'strong', whatever we mean by that. It feels almost personal, like being insulted. You don't want to imagine yourself failing or giving up, so you convince yourself you would never do that, and it bothers you when a character you somewhat relate to does.

A dramatic moment in the saga, it is no surprise that Padmé's death has created controversy among critics and fans alike. It is also not surprising that this scene, coming near the end of the third prequel instalments, causes readers to compare her actions with those of Leia, whose final film is considerably more victorious and whose children, in the Expanded Universe, cause her intense grief with radically different results. Indeed, it seems unlikely that Leia would lose 'the will to live', resulting in the common comparison of the two figures.

Beyond these two primary figures, however, the two *Star Wars* trilogies contain a variety of minor female characters. Mon Mothma, a leader of the Rebellion in the Original Trilogy, had a brief appearance in the films but has been further explored in the Expanded Universe, including *The Clone Wars*. The prequel trilogy, in addition, introduces quite a few new female characters, including female Jedi, such as Aayla Secura, to the big screen. However, the possibility of female Jedi and expanded female characterization was not new to many *Star Wars* fans – they had been finding it in the Expanded Universe for decades.

The Expanded Universe, especially the novels, introduces hundreds of new characters and storylines into fan imagination. Characters such as Mara Jade, Jaina Solo, Tenel Ka, Aurra Sing, Asajj Ventress, Jocasta Nu and others give readers a variety of fe-

From Bikinis to Blasters:
The Role of Gender in the *Star Wars* Community
Erika Travis

male characters with which to identify: female Jedi and female Sith abound. The added benefit of novelization is that many of these characters and their relationships can be explored in depth, an aspect that many female fans enjoy. It is important to note that many male fans, such as those posting to the 'LucasForums' message boards and others, are also interested in stronger female characters, particularly Jedi. A set of 'EUCantina' editorials recently sparked controversy over whether or not it was acceptable for female fans to call for more female leads within the novels, and the resulting comments and message board debates illuminate the tension that still sparks over gender representation in the *Star Wars* Expanded Universe.

The Clone Wars (2003 – 2005) animated television series occupies a space between the big screen and the rest of the Expanded Universe. It has the mass media appeal of the films, while its serial nature allows time for backstories, relationships and new characters to be explored. One such new character is Ahsoka Tano, Anakin's padawan. Ahsoka, who is young, fierce and fiery, often challenges Anakin and saves his life on several occasions. She is compassionate and feminine, without being overtly sexualized. She breaks the mould Leia and Padmé cast in several important ways: she is a Jedi rather than a politician, she is adolescent rather than a young adult, and she is a Togruta rather than a human. These differences allow her to break clearly away from fairy tale typology and explore other aspects of the female identity, such as coming of age and diverse ideas regarding femininity, important to new generations of *Star Wars* fans.

As a logical consequence, as the number of female characters within the *Star Wars* universe increases, their portrayal is becoming more complicated; some characters are progressive while others remain true to traditional archetype and motifs. In many ways, these characters reflect the variation within the fans who follow them. *Star Wars* fans are not a homogenous group, and they do not share a unified voice. Fortunately, the online communities of recent years have allowed fans greater access to one another and expanded opportunities to make individual voices heard.

The majority of online *Star Wars* fan communities are operated by men, but more and more frequently with women on staff or serving as moderators. Others, such as 'Club Jade', 'The Moons of Lego' and '*Star Wars* Chicks', are operated (mainly) for women by women. There are also numerous 'geek girl' websites run by female science-fiction, fantasy and/or pop culture fans that include significant discussion of *Star Wars* related themes: popular examples include 'FANgirl the Blog', 'Pink Raygun', 'Geek with Curves' and 'Girls Gone Geek'. These websites post *Star Wars* news, editorials, reviews, and their 'female viewpoint'. Vlogger Jennifer Landa is one female fan who expresses her 'geek girl' viewpoint by posting what 'The Official *Star Wars* Blog' calls her 'witty, adorkable' videos of her cosplay, *Star Wars* fashion and crafting.

So, we see that female fans' voices can be seen throughout the message boards of the *Star Wars* online community, but is their input respected? The answer to this question seems as varied as the message boards themselves. Often no commentary related

Fig. 3:
Mechandise for young and
proud female fans
(www.heruniverse.com).

to gender is made, and uniform message fonts diminish the truth of participants' diverse backgrounds. In fact, unless a participant chooses to disclose his or her gender, or race or age, an ambiguous screen name and avatar can completely erase demographic indicators. Most participants, however, choose online personas that reflect, to some extent, their actual gender. There have certainly been instances where female fans have felt their responses were dismissed as 'emotional' or 'uninformed' solely because they are female, but just as often, if not more, discussions are focused more on content than contributor.

Online *Star Wars* communities have also created the opportunity for a more formal academic fan response. The online fan academic journal *Saga Journal*, which posted essays from 2004–10 and is still online, has an editorial team made up almost entirely of female fans, and a majority of their articles are authored by women. The site has posted several articles examining the women of *Star Wars* including Leia, Padmé, Shmi and Beru.

One online community in which female fans play a primary role is that of fanfiction. A 1981 survey by Pat Nussmen revealed that many fans thought that 'the creativity aspect of media fandom is mainly restricted to women because that fandom "ain't in it for the money," while men, according to the mores of society, are in creative pursuits only because of money'. While this may seem rather reductive, Nussmen also notes that the gender disparity seen in the films may give rise to an opposing disparity in fanfiction. If fanfiction writers, at least in some cases, write to insert themselves into a relationship plot with pre-existing characters, there are simply more male partners to choose from.

Members of the online *Star Wars* community had an interesting opportunity to reach out to one young female *Star Wars* fan in 2010 when columnist Carrie Goldman wrote an article about her first-grade daughter, Katie, being bullied for bringing her *Star Wars* water bottle to school. *Star Wars* bloggers around the web, including Bonnie Burton of 'The Official *Star Wars* Blog', posted the story and fans, male and female, responded by

From Bikinis to Blasters:
The Role of Gender in the *Star Wars* Community
Erika Travis

posting hundreds of encouraging messages and even mailing her *Star Wars* toys. This incident highlights the tension that remains in *Star Wars* fandom: there are male fans who adhere to the 'boys club' idea, but there is a much larger community, made of male and female fans, that has put that myth behind them.

Perhaps part of the reason the stereotype that *Star Wars* fandom is predominately male populated is that a majority of *Star Wars* merchandise is still directed at male consumers. While sites like Etsy and Ebay may have a nice variety of unlicensed merchandise, often made by female fans, licensed merchandise is more restricted. Action figures and Lego make up the majority of readily available *Star Wars* toys for purchase. While some may argue that these are not inherently 'boy toys', they invariably seem to be placed in the boys section of the local Toys "R" Us, Target or Walmart, or whatever your local toy stores may be.

With the prequel movie releases, there were a few 12-inch style dolls for purchase, but these were quickly relegated to the collector's department. In a similar vein, Disney theme park offered an Amidala Polly Pocket play-set that enjoyed relatively limited distribution. This is not to say that female fans have not been a power in the consumption of *Star Wars* merchandise, just that more toys are produced with male consumers in mind. Female fans are also large purchasers of these 'boy toys'. PLJ, of the '*Star Wars* Shrine: A Female Fan's Guide to Collecting' website, like many other female fans, has shelves and shelves of these 'boy's toys'. However, she also has a link to a petition asking for more Robert Tonner collectible *Star Wars* dolls and comments, 'As a collector, females sit on the sidelines hoping and praying that some sort of a pretty bone will be thrown our way'. While many female fans are willing to purchase 'male' merchandise, they would be even more excited to purchase merchandise intended for them.

Ashley Eckstein, voice of Ahsoka Tano in *The Clone Wars*, felt this need as a female fan and decided to do something about it. She started Her Universe, a clothing company that sells 'geek chic' clothing and accessories for women and girls. The line began with licensed *Star Wars* merchandise and has added a variety of pieces from the SyFy universes. In an interview with 'TheForce.net', Eckstein stated that her reasons for starting the line were simple: 'Almost 50% of *Star Wars* fans are women, and it made no sense that 80% of the consumer market and 50% of *SW* fans are female. [...] Why was there nothing for them to buy? Then I began reading all of the girls' comments online, and I realized that girls have been begging for female *SW* merchandise for years'. Eckstein attends events such as Disney's *Star Wars* Weekends, Celebration events, and various ComicCons, where she debuts new distinctly female designs, often inspired by fanart. Eckstein emphasizes the importance of fan support, both male and female. An article from 'BoulderWeekly.com' reports her saying, 'The male gender has been so supportive. I would say we had just as many guys at our booth (at Celebration) as girls because they're buying for their wives, their daughters, their girlfriends, their sisters, and the nice thing is that they've all been supportive. Honestly, the guys have come up and

said, "Thank you. I've wanted to get something for my daughter".'

The father-daughter dynamic of *Star Wars* is nothing new – after all, there's always been the Vader-Leia relationship – but it is a dynamic that fans are embracing in a considerably more functional way than the Skywalker family. As discussed in more detail in Chapter 9, boys who grew up as *Star Wars* fans become fathers, they often pass their fandom on to their children, male and female. With the release of the prequels, release of the 3D versions, and *Star Wars* early reader books, and the relatively child friendly *The Clone Wars* (2003 – 2005) animated series, a new generation of *Star Wars* fans have plenty to be excited about. Young girls in particular may have even more reason to join the fandom than previous generations. Aside from the young girl role model Ahsoka Tano and the possibility of pink Ewok shirts, they have *Star Wars* dads *and* moms. The little girls who played a different kind of princess are now Leia-moms, female fans who grew up with the original series and are now strong, smart, powerful role models in their own right.

While Leia-moms come in all shapes, sizes and personalities, they are all *Star Wars* fans who share their fandom with their children. It may be baking from *The Star Wars Cookbook: Wookie Cookies and Other Galactic Recipes*, sewing (or buying) costumes for Halloween and dress-up play, or decorating the nursery with *Star Wars* ABC's from Etsy. For some women, it's reading *Star Wars* bedtime stories, constructing crafts from *The Star Wars Craft Book* or shopping for themed apparel. And it very likely includes building Hoth snow forts in the backyard, or engaging in lightsaber duels in the family room. It may even involve a family movie night or six. Whatever it means to each Leia-mom, it means that in some small (or not so small) way she has followed in the Princess's footsteps – retaining her passion, fiercely loving her family and maintaining her femininity, even while fighting to bring peace to the galaxy, or at least the living room. Emily of the Tosche Station blog puts it this way: 'I wanted to be Tenel Ka and Mara Jade when I grew up [...]. I hope that I've become that person. And more than that, I hope that I've learned to embody that strong female role – and that my own daughter will want not only to be Tenel Ka and Mara Jade, but to be her mother as well'.

Couples who share a love of *Star Wars*, whether they met at a convention, cantina or more traditional setting, pass that love on to their children. Such fans are raising both their daughters and their sons to dress up in *Star Wars* costumes, read Expanded Universe books, play *Star Wars* video games and attend events together. *Star Wars* Celebration VI this year has family pricing options, and the face of the costume pageant page is neither a sexy woman in a metal bikini nor a little blond-haired Luke, but rather a tiny (and adorable) preschool Princess Leia. Male and female fans together continue to remind the media, merchandisers and the occasional message board or playground bully that *Star Wars* fandom is big enough for everyone, leading many to believe that female fans, young and old, will find truly equal footing within the fandom, and male fans will find out how many kindred spirits they have among the opposite sex in a universe not so far away after all. ●

From Bikinis to Blasters:
The Role of Gender in the *Star Wars* Community
Erika Travis

~~~~~~~~~~~

## GO FURTHER

### Books

*The Hero with A Thousand Faces*
Joseph Campbell.
 (Princeton, NJ: Princeton University Press, 1972)

### Extracts/Essays/Articles

'Why Star Wars Needs Women – Now More Than Ever'
Emily
At 'Tosche Station', 6 May 2012,
Available at: www.tosche-station.net

'EU Action/Reaction: Let's Stop Thinking About Gender'
Chris
At 'EUCantina.net', 4 May 2012,
Available at: http://www.eucantina.net/archives/11915

'The GFFA Needs Women: The Disappointing Nomi Cancellation'
Nanci
In 'EUCantina.net', 1 March 2012,
Available at: http://www.eucantina.net/archives/11959

'About Padmé 's Death'
chameleon_irony
At chameleon-irony's 'LiveJournal', 21 February 2012,
Available at: http://chameleon-irony.livejournal.com/41848.html

'10 Most Undignified Deaths in Science Fiction and Fantasy'
At 'io9', 24 January 2012,
Available at: www.io9.com

'Meet *Star Wars* Vlogger Jennifer Landa'
Bonnie Burton
At 'The Official Star Wars Blog', 2011,
Available at: http://tinyurl.com/chnqpkc

Young Girl Bullied for Liking *Star Wars*'
Bonnie Burton
At 'The Official *Star Wars* Blog', 18 November 2010,
Available at: http://tinyurl.com/23sl34w

'"Star Wars" actress broadens souvenir universe for female fans'
At 'BoulderWeekly.com', 27 September 2010,
Available at: http://tinyurl.com/d7d793j

TFN Interview: Ashley Eckstein'
Mandy
At 'TheForce.net', 10 May 2010,
Available at: www.theforce.net

'Feminism and the Force: Empowerment and Disillusionment in Galaxy Far, Far Away'
Diana Dominguez
In Carl Silvio and Tony M. Vinci (eds). *Culture, Identities and Technology in the Star Wars Films: Essays on the Two Trilogies*
(Jefferson, NC: McFarland, 2007), pp. 109–33.

'"Distressing Damsel": Padmé Amidala as Fairytale Heroine'
Lady Aeryn
At 'Saga Journal', November 2006,
Available at: www.sagajournal.com'The Perils of Padmé: The Short Life and Fast Times of a Tragic Heroine'
lazypadawan
Ar 'Saga Journal', August 2005,
Available at: www.sagajournal.com'"Star Wars" Heroes Slay Stereotypes'
Lois Hatton
*USA Today*, 30 June 2005,
Available at: www.usatoday.com

'Princess Leia and the Woman Warrior'
lazypadawan
At 'Saga Journal', April 2005,
Available at: www.sagajournal.com'Where the Boys Are'
Pat Nussmen
In *ALDERAAN: The Star Wars Letterzine*, (no. 15, 1981), pp. 2–3.

**From Bikinis to Blasters:**
**The Role of Gender in the *Star Wars* Community**
Erika Travis

## Websites

'Club Jade', www.clubjade.net

'FANgirl the Blog', Tricia and Lex, www.fangirl.com

'Geek with Curves', www.geekfemme.blogspot.com

'Girls Gone Geek', www.girls-gone-geek.com

'Her Universe', www.heruniverse.com

'lack of strong female jedi?', Lucas Forums, www.lucasforums.com

'Leia's Metal Bikini', www.leiasmetalbikini.com

'The Moons of Iego', http://moonsofiego.thepensieve.net/

'Pink Raygun', www.pinkraygun.com

'Slave Leia PSA', Nerd Machine TV, with Kaley Cuoco,
http://www.youtube.com/watch?v=_wM_OUZGdBs

'*Star Wars* Celebration VI', www.starwarscelebration.com

'Star War Chicks', www.starwarschicks.com

'Star Wars Shrine: A Female Fan's Guide to Collecting', www.starwarsshrine.wordpress.com

# AREN'T YOU
# A LITTLE SHORT
# FOR A
# STORM TROOPER?

**PRINCESS LEIA**
A NEW HOPE

Chapter
6

# Jediism as Religion? The Force as Old/New Religious Philosophy

## Zachary Ingle

→ It is natural for fans to either emulate or adapt the customs, lifestyles and beliefs inherent in their object of fandom. *Star Wars* may be one of the textbook cases for this type of fan devotion, as fans have appropriated the various philosophies in the saga.

Fig. 1: Cover of Kevin S. Decker and Jason T. Eberl's Star Wars and Philosophy.

The contributors to *Star Wars and Philosophy* (edited by Kevin S. Decker and Jason T. Eberl) note varying philosophies exhibited in the stories and characters within the *Star Wars* universe, including religious pragmatism, speciesism, existentialism, scepticism, dualism, determinism, environmental ethics, Zen Buddhism and bioethics, with philosophers such as Plato, Aristotle, Augustine, Hume, Hegel and Heidegger frequently referenced. Characters such as Han Solo and Jango Fett are described as ethical egoists, Lando Calrissian as a utilitarian and Yoda as a Stoic. While George Lucas's space saga certainly can be illuminated with these philosophies in mind, it is his concept of the Force that seems to be the philosophical/religious contribution for which *Star Wars* remains best known.

Han Solo may have little use for 'hokey religions', yet many *Star Wars* fans argue otherwise. *Star Wars* attracted numerous fans through its archetypal story in a canvas filled with groundbreaking special effects, but many also became engrossed in the core metanarrative that undergirds the *Star Wars* universe – the Force. The expansiveness of the *Star Wars* universe makes this metanarrative – the Force that binds us and penetrates us – so attractive. Functioning as a religious signifier for *Star Wars* fan community, 'May the Force be with you' became the most common greeting among them. The vehicles, vessels and weapons have always had a ready appeal for *Star Wars* fans, but for others it is this concept of the Force and the mystery of the Jedi and Sith orders that are the most intriguing aspects of a series of films that became sacred texts. (It's not called the 'Holy Trilogy' for nothing.)

In *A New Hope* (Lucas, 1977), it is Obi-Wan Kenobi who first introduces the concept of the Force: 'The Force is what gives a Jedi his power. It's an energy field created by all living things. It surrounds us and penetrates us. It binds the galaxy together'. Only minutes later in the same film, Darth Vader speaks of the Force in equally glowing terms: 'The ability to destroy planets is insignificant compared to the power of the Force'. In *The Empire Strikes Back* (Kreshner, 1980), arguably the most philosophical film in the Original Trilogy, Yoda instructs Luke (and us) on the ways of the Force: For my ally is the Force, and a powerful ally it is. Life creates it, makes it grow. Its energy surrounds us and binds us. Luminous beings are we, not this crude matter [*pointing to Luke's arm*]. You must feel the Force around you; here, between you, me, the tree, the rock, everywhere, yes.

In *The Phantom Menace* (Lucas, 1999), Qui-Gon Jin expands on the 'theology' of the Force, referring to the 'living Force' and the 'will of the Force', while also introducing the role of midi-chlorians, the microorganisms and symbionts that not only have the ability to communicate with the Force, but can also infuriate fans to no end. Based on endosymbiotic theory, this became one of the biggest controversies in the wake of *The Phantom Menace*.

Although the Jedi order maintains a highly visible presence in the galaxy in the prequels, they seem to have been forgotten by the time of *A New Hope*, when their beliefs are now perceived as 'ancient,' 'hokey' or 'simple tricks and nonsense'. In *A New Hope*, Han Solo, Grand Moff Tarkin and Admiral Motti all refer to the Jedi or belief in the Force

## Jediism as Religion?
### The Force as Old/New Religious Philosophy
Zachary Ingle

as a 'religion' and express their faithlessness in an 'all-powerful Force controlling everything'. Solely based on this first entry in the saga, it is apparent that most in the galaxy put their faith in technology (specifically weapons of warfare, i.e., blasters and the Death Star), not in things unseen.

Part of *Star Wars*' charm in postmodernity exists in its dualistic worldview of the light side and dark side of the Force, a worldview seemingly indebted to previous dualistic religions in the ancient and medieval world, such as Zoroastrianism, Manichaeism, Mandaeism and Bogomilism. But is the *Star Wars* universe really a dualistic one? In other words, has the Force always had its light side and dark side, eternally in conflict? Theologian John C. McDowell notes how we are thrown *in medias res* of the *Star Wars* universe. There are no indications that the dark side of the Force existed co-eternally with the light side. (Notice also that there is not a *Dark Force* and a *Light Force*, but rather a dark side and light side of the same Force.) Also, the Sith are typically presented as fallen Jedi. Thus, to borrow Augustine's concept, evil (i.e. the dark side of the Force) in the *Star Wars* universe is a *privatio boni*, a perversion or privation of the good (i.e. the light side of the Force).

A theist who has labelled himself a 'Buddhist Methodist', Lucas has typically been forthright concerning his decision to institute his concept of the Force into his space opera. In a 1979 interview, Lucas stated, 'The Force evolved out of various developments of character and plot [...] I began to distil the essence of all religions into what I thought was a basic idea common to all religions and common to primitive thinking. I wanted to develop something that was nondenominational but still had a kind of religious reality'. Or as Lucas biographer Dale Pollock articulates, 'The Force embraces positive Oriental philosophies and the Judeo-Christian ethic of responsibility and self-sacrifice'. Thus, the Force is really an amalgamation of several world religions; any reliance on one in particular would be too naïve.

Lucas' indebtedness to Joseph Campbell's work on comparative mythology in constructing his own mythology has often been recounted. But for the concept of the Force in particular, Lucas was inspired by Carlos Castaneda's science-fiction novel *Tales of Power*, which mentions a 'life force'. Several commentators have also noted the parallels between the Force and Eastern religions, particularly Zen Buddhism and Taoism. Kevin J. Wetmore, Jr. labels Yoda the 'Taoist master of the Star Wars universe', identifying the connections between the diminutive green figure and Lao Tzu. If anything, the prequels have made the connections to Taoism more palpable, with the handful of references in episodes I–III of Anakin bringing balance to the Force. Debuting in 2012, the first *Star Wars* story to take place in the pre-Republic era (to be precise, 36,453 years before the Battle of Yavin), the *Dawn of the Jedi* comic book series tells the untold history of the Je'daii Order, precursors of the Jedi. This group differs from the later Jedi in that they are constantly concerned with seeking the appropriate balance between the light side and the dark side of the Force. This renewed emphasis on balance, less of a

Fig. 2:
*Dawn of the Jedi comic book.*
© *Dark Horse Comics*

Fig. 3:
Logray from Ewoks, Star Wars
Animated Aventures © 1985-
1987 Nelvana, Lucasfilm

concern in the original films, substantiates Taoism's place in the *Star Wars* mythos, and has increasingly become a part of fan discourse. Yoda's view of the material world ('Luminous beings are we, not this crude matter') is yet another Eastern religious marker found in the films. Jedi enlightenment apparently involves a negative view of the physical world, contrasting with the positive view of it found in Jewish and Christian scriptures, which state that God will redeem his creation.

Although Lucas confesses to borrowing from a mélange of Eastern religions, several commentators have also noticed Christian parallels. These range from the obvious (Anakin's virgin birth, admittedly a common mythological theme) to the less so. Some speculate that Lucas incorporated the concept of midi-chlorians into the *Star Wars* universe in order to give it a more scientific rationale, but Qui-Gon Jinn's description of their role ('They continually speak to us, telling us the will of the Force'), as well as their role in Anakin's mysterious birth, makes them sound more like the Holy Spirit. Lucas admits to including a Christ story in *The Empire Strikes Back*, as Luke (the Christ figure) faces the temptation of Vader (the Devil figure) in the cave and in their encounter in the film's climax. Of course, the whole father-son dynamic breaks down this parallel. Emphasis on a messiah figure was there in the 'Journal of the Whills', one of the earliest drafts of what would later become *A New Hope*: 'And in the time of the greatest despair there shall come a savior, and he shall be known as THE SON OF THE SUNS' ('Journal of the Whills' 3:127). Luke may have been the fulfilment of this 'messianic' prophecy in this early incarnation, but it would be his father, Anakin, who several characters in episodes I–III would identify as the 'Chosen One' of the 'prophecy'. (The prophecy is only alluded to, as there is no mention in the films of Jedi holy texts, despite the impressive Jedi library.)

Despite the Force serving as the dominant religious path in the films, there are a few other religious references worth noting. While not mentioned by name, the possibility of deities are sometimes broached. The Ewoks mistake C-3PO for a deity in *Return of the Jedi* (Marquand, 1983), and when Han encourages him to exploit his 'divine influence', C-3PO refutes his command: 'It's against my programming to impersonate a deity'. In *The Phantom Menace*, Jar Jar Binks knows that 'maxi big da Force', but still refers to 'the gods'. (Since this is in reference to a Gungan tradition, one can presume that their observance is localized to this species.) The Expanded Universe reveals more alternatives to the Force metanarrative, including the possibility of deities. For instance, in the *Ewoks* animated series (1985–87), the titular species – perhaps because of their primitivism? – practice animism, magic and shamanism, while also practicing abeyance to a pantheon of deities, including the Light Spirit. Even further afield in the Expanded Universe, you find the religious cult in the Han Solo novel, *The Paradise Snare* (by A. C. Crispin). As of May 2012, the *Star Wars* wiki, Wookiepedia, contains entries on

## Jediism as Religion?
### The Force as Old/New Religious Philosophy
Zachary Ingle

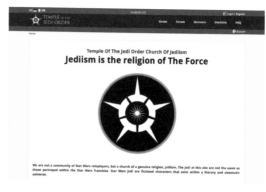

117 deities identified in the Expanded Universe. Fans have also contributed pages on dozens of 'churches', cults, religions (most unique to a planet or species) and religious concepts, all that fall outside of the dominant religion of the Force. Furthermore, although the Jedi and Sith come to the mind foremost when thinking of the Force, fans on Wookiepedia have also identified over 70 other Force-sensitive groups in the Expanded Universe.

Several books have explored the relationship between *Star Wars* and existing religions in depth. These include books on Buddhism (Matthew Bortolin's *The Dharma of Star Wars*), Taosim (John M. Porter's *The Tao of Star Wars*) and Hinduism (Steven J. Rosen's *The Jedi in the Lotus: Star Wars and the Hindu Tradition*). Although not a complex work as it is more of a devotional nature, *The Dharma of Star Wars* helpfully connects the Force to the Buddhist concepts of nirvana, meditation, the five aggregates and the eightfold path, among others.

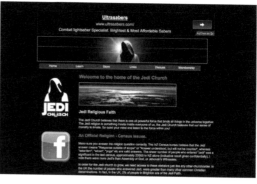

Fans have also authored several works on the parallels between *Star Wars* and Christianity, appropriating their beloved saga to their own religious beliefs. The Force may not be the personal God of Christianity, but it is a 'ground of being', a supernatural energy, something so significant that even the Death Star's ability to destroy planets pales in comparison. One can see its ready appeal to the spiritually-minded. As early as 1977, Frank Allnut's *The Force of Star Wars: Unlocking the Mystery of the Force* views *A New Hope* with a futurist reading of the Book of Revelation in mind. He compares the Force to God, the Rebellion to the Church, Obi-Wan to Jesus, Leia to Israel, the Emperor to Satan and Darth Vader to the Antichrist. Han and Luke apparently represent Gentile and Hebrew Christians, respectively. Of course, the revelations of *The Empire Strikes Back* would undermine this admittedly bizarre interpretation. Over twenty years later, several more books on *Star Wars* and Christianity would appear (see the bibliography). Most of these books are of a devotional nature (Timothy Paul Jones concludes each chapter in *Finding God in a Galaxy Far, Far Away* with 'Spiritual Exercises for the Serious Padawan' along with meditations on the 'True Force') and most were published in 2005 to capitalize on the release of *Revenge of the Sith* (Lucas, 2005). But McDowell's *The Gospel According to Star Wars: Faith, Hope, and the Force* sets itself apart from this group with its scholarly approach, as he wrestles with *Star Wars* vis-à-vis the Christian theological tradition. McDowell notes, 'There is a yearning in our world for a spirituality that can resolve the tensions between religion and power with integrity, and if S[tar] W[ars] is unable to identify what that might look like, it has at least the courage to try to imagine its possibility and reveal our need of it'.

Some fans have taken their love for *Star Wars* even further, with 'Jediism' becoming a new religion and/or philosophy. In his study of *Star Wars* fandom, Will Brooker notes that for some fans 'the *Star Wars* saga is cited not just as a supplement that illustrates and parallels existing religion, but as a workable, persuasive ethical system that traditional religion has failed to provide'. Websites dedicated to those who have taken this next step include www.jedichurch.org (which includes doctrinal statements and marriage vows, also justifies its newness by comparing it to Scientology), www.churchofjediism.org.uk, www.newjediismorder.org and www.orderofthejedi.org (replete with liturgy). Most of the groups emphasize that Jediism is not an exclusive religion; its users may remain Christians, atheists, Buddhists or whatever religion to which they already adhere. This is why some websites prefer the term 'philosophy' over 'religion'.

In 2005, the Temple of the Jedi Order, headquartered in Beaumont, Texas, was officially recognized as a non-profit religious organization by the state of Texas. Its website (www.templeofthejediorder.org) promotes a creed that is almost the Prayer of Saint Francis [of Assissi] verbatim, except that each stanza concludes with 'I am a Jedi'. Six special interest groups exist, depending on whether a member Jedi is of 'pagan', 'Abrahamic', 'Buddhist', 'realist-humanist' or just plain old 'Jediism' or 'Sithism' persuasion. Eleven feast or holy days are listed, with 4 May noticeably absent. There is also a hierarchy of offices, from a simple Temple Member to a Grand Master. 'Sermons' are regularly posted, and there are exercises for initiates. Under 'Temple Doctrine' they state:

Jediism is a syncretistic religion – a faith involving elements from two or more religions including Taoism, Shintoism, Buddhism, Christianity, Mysticism, and many other Religions' universal truths and a combination of martial arts and the Code of Chivalry. These philosophies are the heart of Jediism; not the wonderful *Star Wars* movies themselves except to serve as parables.

The latter statement's sentiment is echoed in most of these groups' websites as they seek to distance themselves from any accusations of following a religion that is based on a movie. They also do not 'worship' the Force, even if some followers do 'believe in the Force and its power'.

The rise of the Jedi 'religion' has garnered media attention in census controversies in several English-speaking countries. In 2001, 0.79% of British citizens marked 'Jedi' as their religion on the census, more than the number of Sikhs, Jews or Buddhists in the UK. Jedi adherents were primarily concentrated in areas with a higher student population, with the city of Brighton and Hove leading the way with a Jedi population of 2.61%. That same year, 20,000 Canadian citizens stood in solidarity with their fellow Jedi across the pond. Australia had similar results. New Zealand led them all, however, with 1.5% Jedi population according to the 2001 census, making it second only to Christianity. Promoted through Internet campaigns, the motives behind many of those who

Jediism as Religion?
The Force as Old/New Religious Philosophy
Zachary Ingle

claimed Jedi may have been to take a jab at bureaucracy, as many thought that national governments would have to recognize it as an official religion if it received enough votes, while some used it as a tool to criticize governments for asking such a personal question. But it should not be overlooked that there were certainly some who took it more seriously, like the fans who ascribe to the above organizations.

Interestingly, despite the shadow the prequels cast on the origins of the Force, the ambivalence among *Star Wars* fans towards episodes I–III does not seem to have affected the rise of Jediism. But Wetmore remains sceptical about the future of this new 'religion':

Only someone with no connection to reality believes that the Force is an actual principle that influences and shapes our lives. We might compare the Force to the divine, the numen, the holy, or specific deity-figures, but it is not real nor does it have a social or cultural effect as other religious belief structures do. The *Star Wars* films can give an individual's life meaning, create a social order within its fan culture, inspire their viewers individually and collectively, offer a life-changing experience, and even give the viewer a transcendent experience. But for all that it still does not offer a complete 'metaphysical-mystical prospect'.

Much of the appeal of the *Star Wars* universe lies in its relatable characters, Wookies and AT-ATs, its lightsabers and its bounty hunters, but surely the Force must be credited for some of its popularity. Apparently, the flexibility of the Force speaks to its fans, whether they create a new spirituality out of it or adapt it to already-held beliefs. Lucas admitted to Bill Moyers in a 1999 interview that he wanted to invoke a spiritual awakening among young people. Pollock concurs: 'Lucas wanted to instill [sic] in children a belief in a supreme being – not a religious god, but a universal deity that he named the Force, a cosmic energy source that incorporates and consumes all living things'. So, was it, indeed, *Star Wars* that gave organized religion, especially in America, a shot in the arm in the disillusioned, nihilistic 1970s? According to Pollock, 'The message of *Star Wars* is religious: God isn't dead, he's there if you want him to be'. In an age of increasing dependence on technology and where science trumps spirituality, Darth Vader stood up and proclaimed, 'I find your lack of faith disturbing'. ●

~~~~~~~~~~~~~~

GO FURTHER

Books

The Gospel According to Star Wars: *Faith, Hope, and the Force*
John C. McDowell
(Louisville: Westminster John Knox Press, 2007)

Star Wars and Philosophy: More Powerful Than You Can Possibly Imagine
Kevin S. Decker and Jason T. Eberl (eds)
(Chicago: Open Court, 2005)

Finding God in a Galaxy Far, Far Away: A Spiritual Exploration of the Star Wars Saga
Timothy Paul Jones
(Sisters, OR: Multnomah, 2005)

The Dharma of Star Wars
Matthew Bortolin
(Boston: Wisdom Publications, 2005)

Christian Wisdom of the Jedi Masters
Dick Staub
(San Francisco: Jossey-Bass, 2005)

The Empire Triumphant: Race, Religion and Rebellion in the Star Wars *Films*
Kevin J. Wetmore, Jr.
(Jefferson, NC: McFarland, 2005)

Using the Force: Creativity, Community and Star Wars Fans
Will Brooker
(New York: Continuum, 2002)

Skywalking: The Life and Films of George Lucas
Dale Pollock
(Hollywood: Samuel French, 1990)

Chapter
7

Greater than the Sum of its Parts: The Singular Emergent Language of the *Star Wars* Universe

Kris Jacobs

→ Jedi. Wookie. Sarlacc. Sith. Padawan. Ewok. Gungan. If you're reading this book, there's a better than average chance that these words are quite familiar to you. There's an equally good chance that hearing them spoken or seeing them written down – these or any number of others like them – evokes certain clear and specific images in your mind.

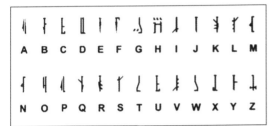

Fig. 1: Mando'a alphabet.

These are terms we've grown up with; words, concepts, ideas that have penetrated into the deep layers of our personal consciousness and our collective mythos; words that have helped, in their own varying ways, make us who we are.

In most cases, for most *Star Wars* fans, such terms as these might easily be taken for granted. The vast connotative power of a single word is often overlooked, despite the fact that it may contain within it the implications of an entire galaxy. Introduced in their respective places throughout the six films and the expanded *Star Wars* universe, these words have extended outward into other galaxies, including our own. Jedi and the rest are a part of our vocabularies now, ours to use as we see fit; to infuse with whatever personal connections the years and the films and the books and the toys have bestowed on each of us. The words and the images they convey belong to us in the same way that the films themselves belong to us, in the same way that Luke and Han and Leia and Anakin and, yes, even Jar Jar belong to us. Legally, both the characters and their words and languages belong to George Lucas, make no mistake about that. But psychologically, culturally, mythologically, they have become our own.

As speakers of our respective languages, we have ready access to thousands of words that we can legitimately – and without concern for trademark infringement or copyright violation – consider 'ours'. As we learn and develop our vocabularies, sometimes expanding our repertoires to the point of delving into entirely new languages and dialects, we add to the store of words we can call our own. This is such a natural process that often we don't even realize it is happening. Words seep into us, become a part of us, without the need for our awareness. They assist us in better describing and relating to the world around us; they aid us in determining our places in it.

For instance: at some point early on in our development each of us presumably learned that the word 'apple' refers to a sweet, red, crunchy fruit that grows on trees and tastes wonderful when made into pies or sauces. This simple piece of knowledge, acquired almost accidentally, helped make our understanding of the universe and the creatures and objects that inhabit it a teensy little bit more complete. Such is the power of a single word.

Likewise, at some point along the way, each of us encountered, let's say, the word 'Jedi' for the first time. If your experience was anything like mine, this encounter wasn't the same as your introduction to other, more ordinary words. This one changed everything. This strange-sounding, exotic word didn't refer to anything I'd ever encountered in the world I was growing up in and did not, so far as I could tell, assist with my understanding of that world in the least. If anything, quite the opposite was true. Instead of learning more about my world, I was plucked clean out of it and thrust into a totally new

Greater than the Sum of its Parts:
The Singular Emergent Language of the *Star Wars* Universe
Kris Jacobs

world about which I knew nothing at all, a world where, incidentally, such things as apples did not even seem to exist. That word 'Jedi' opened a door onto a whole new kind of language, a language that gave understanding not of this world but of another, one that existed a long time ago in a galaxy far, far away. Words can sometimes do that too.

The power of a word to displace rather than to orient is, of course, not unique to *Star Wars*. Imaginative works of fiction and fantasy, whether in the form of books or movies, cartoons or stage productions, have been introducing terminology designed to do precisely that for generations. Humanity's oldest literatures are resplendent with nouns that have no real-world reference, words every bit as exotic as Jedi. Dragon, unicorn, basilisk, orc, goblin, elf, faery, griffon – all these fit that bill, and references to them can be found as far back as our oldest myths and scriptures. In more modern times, writers like Tolkien and Ursula Le Guin and Neil Gaiman, film-makers like Spielberg and Cameron and the Wachowskis, have been introducing new words and new worlds to audiences everywhere.

But somehow *Star Wars* is different...

Let's take that word 'Jedi' again and examine it a bit more closely: From a purely etymological perspective, Lucas has said that he coined the term from the Japanese word *Jidai-Geki*, which means 'period piece' and refers to a genre of film, television and theatre usually set during the Edo period of Japanese history, much of the focus of which is on the great warriors of that day, the samurai. This at least accounts for the lightsaber duels and the tunics, but I think we can agree that the word 'Jedi' captures more than just swords and costumes – more by far. Encapsulated in that little word there is the concept of the Force and the power to manipulate it; there is the responsibility of defending the galaxy from tyranny and evil; there are the Sith, ancient enemies of the Jedi; there are thousands of years of history involving space travel and hyperdrives and Hutts and Death Stars and Mynocks and pod races and clone wars and Gamorrean guards. You begin, perhaps, to see what I mean.

What George Lucas has done with his six films, what the numerous EU authors have done with their hundreds of *Star Wars* books, what the animated series and the action figures and even the zip-open Tauntaun sleeping bags have done is provide us with an entirely new language, made from the fragments of a thousand component parts, complete with its own history, vocabulary, style, syntax and form. This new language is one that takes a tremendous amount of time and great effort to learn; one that is comprised of many other languages, both spoken and imaginary, but that is complete and consistent in itself; one that is made up not just of words, but of particular sound effects as well. The hiss of a lightsaber leaping into deadly life, the howl of a Wookie, the chirp of an astromech droid, the whine of the Millennium Falcon failing to make the jump to hyperspace: each of these is a piece – a word, if you insist – taken from the greater language that can be heard throughout the *Star Wars* universe. As that universe continues to expand, so does the language, growing, evolving, developing the same way natural

languages all do back here on Earth.

As fans we have become fluent without realizing it.

Any language is made up of so much more than just its composite words. The New Oxford American Dictionary has it that a language may be defined as 'the method of human communication, either spoken or written, consisting of the use of words in a structured and conventional way'. Simple enough, but what does that do to the greater point? Instantly recognizable though it may be, Darth Vader's mechanized breathing can't be spoken or written down, and the primitive mumblings of an Ewok certainly aren't a legitimate method of human communication. Fortunately, there are other criteria to consider. A subsequent clause states that language is 'any nonverbal method of expression or communication', which brings us a little bit closer by opening the door for components other than just words. But it's the second stand-alone definition that really gets us closest to the mark: their language is 'the system of communication used by a particular community or country'. And that pretty much settles it.

The community of Star Wars fans is spread over vast areas of space and time. It crosses ethnic and cultural lines; it spans the generation gap; and it shatters the barricades of class and status. The Star Wars community may very well be one of the most diverse conglomerations on the planet, but its members are held together in close commune by a bond every bit as strong as that which unites speakers of French or Hindi or Swahili. Put a group of people whose everyday languages have nothing in common into the same room and they will obviously experience great difficulty in communicating with each other. However, if that same group is comprised of Star Wars fans, a single simulated howl from Chewbacca will have as strong a unifying effect as if C-3PO himself were there to translate for them all. That one sound – or any one of a whole host of others – has the extraordinary ability to establish commonality, a link of understanding, between otherwise completely disparate and isolated individuals.

An experiment like this succeeds because the many sounds that emanate from George Lucas' universe are the exclusive province of that universe. There are many kinds of howls accessible to the human experience, but only one kind that belongs to the mighty Chewbacca. Likewise, there are many ways in which one might imagine machine-assisted breathing could sound, but that iconic vacuous sucking sound alternating with that soft whoosh of outgoing air can only belong to Lord Vader. The same is true of R2's chirps and squeaks, of Salacious Crumb's hideous cackle, of the bleats of a running Tauntaun. These sounds are unmistakable and can be heard nowhere else other than inside the boundaries of the Star Wars universe. To an aficionado, hearing one of

Greater than the Sum of its Parts:
The Singular Emergent Language of the *Star Wars* Universe
Kris Jacobs

Fig. 3: The Galactic Phrase Book and Travel Guide by Ben Burtt and Aragomes.

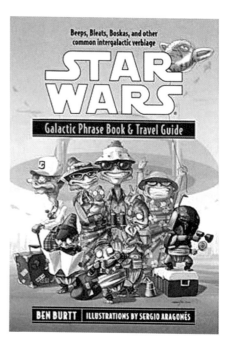

them in an unexpected place can have the same effect as hearing a cheerful '*bonjour!*' might have on a lonely Frenchman abroad.

Much of this universal recognizability is due to the efforts of Lucas' principal sound designer Ben Burtt, who developed many of the audio effects unique to *Star Wars*, including the lightsaber, Darth Vader's breathing, and the 'voice' of R2-D2. Burtt's innovative sound engineering techniques, such as combining recordings of a projector's humming motor with the buzz of a TV picture tube to get that basic lightsaber sound, have been well-documented, and with four Academy Awards to his credit, he is generally acknowledged as one of the best in the business. Burtt has used similar innovations to create sounds for other films like *Raiders of the Lost Ark* (Spielberg, 1981) and Pixar's *WALL-E* (Stanton, 2008), but creative and unique though it may be, none of his other work has come close to obtaining the iconic cultural status of that buzzing lightsaber or any of his other memorable *Star Wars* sounds. Even the swoosh and crack of Indiana Jones' whip doesn't measure up in the collective cultural memory. In the *Star Wars* universe, sounds are transformed into something more than just sounds; they become pieces of the greater language. They become capable of conveying meaning.

Burtt was also instrumental in the development of many of the languages spoken by alien characters in the films. He has written a book entitled the *Star Wars Galactic Phrase Book & Travel Guide*, which serves as an introductory course in most of the languages one might run across in the *Star Wars* universe. In an interview with *Film Sound Today* he explains how the Ewok language came together by layering snippets of Tibetan, Mongolian and Nepali languages. Burtt says:

I broke the sounds down phonetically, and re-edited them together to make composite words and sentences. I would always use a fair amount of the actual languages, combined with purely made-up words. With a new language the most important goal is to create emotional clarity.

It's fair to say that Burtt achieved that goal again and again with his work on the languages of *Star Wars*. The level of clarity he refers to is precisely what allows us to understand what R2 or Chewbacca are saying, despite the fact that neither of them ever speaks – are not capable of speaking – a single word of English. Certainly, body language plays a role here as well. When the shield doors close, leaving Han and Luke trapped out in the freezing Hoth night, for example, the thrown-back head of Chewbacca followed by his leaning forward in mournful despair convey the Wookie's mood as much as the howl and melancholy grumbles that accompany them. But it is those sounds – the pieces of that greater language – that we remember more clearly. When R2's chirps rise

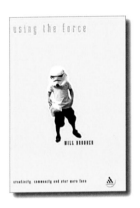

Fig. 4: Will Brooker's ground-breaking study of Star Wars fans: 'Using the Force'.

in pitch at the end, we know without a doubt that he is asking a question; when they descend into the lower register, we can hear the disgust in his tone just as clearly.

There are even instances in which those characters who *do* speak English aren't as well understood. In Will Brooker's 2002 book *Using the Force*, for instance, one of the author's friends states that, 'They tried to make Jar Jar like between R2 and Chewbacca. But you could never understand what Jar Jar Binks was saying'. The clear implication here is that, even though Jar Jar's pidgin – described by *The Nation*'s Patricia Williams as an insulting 'mush of West African, Caribbean, and African-American linguistic styles' – might have been more closely connected to an actual language, it missed the mark, and R2 and Chewy remain, albeit imperfectly, more acceptably coherent.

Emotional clarity might be enough for Ben Burtt, but some critics of how alien languages have been employed across the *Star Wars* franchise tend to disagree. In a *New York Times* article praising James Cameron's creation of a fully-functioning Na'vi language for his 2009 film *Avatar*, Ben Zimmer scoffs at *Star Wars*, saying by way of comparison that 'the jabbering of the various alien races [...] never amounted to more than a sonic pastiche'. Zimmer's point is well-taken, and perhaps Huttese and Kikuyu and some of the rest, of which only snippets and disconnected fragments are decipherable from the films, might have been better served with a bit more development.

Some of the fans out there are working toward precisely that. On her website, Karen Traviss, author of several *Star Wars* Expanded Universe novels, has developed Mando'a, the language of the Mandalorian clans of which Boba Fett was a member, into something that far exceeds anything seen or heard in the films, providing a glossary of hundreds of terms as well as clear rules for grammar and usage. Similarly, word and phrase translators developed by fans can be found all over the Internet that allow for easy back and forth movement between Earth-based languages and most of the languages of the *Star Wars* universe. Perhaps one of the best web-based sources for exploring these languages is 'The Complete Wermo's Guide to Huttese (and other *Star Wars* languages)'. The author of this site has been compiling glossaries for the respective canonical tongues for years, and while she admits it remains a work in progress, the amount of information she has accrued, coupled with a host of links to other similar sites, make what she has already done impressive – most impressive.

These kinds of efforts are admirable and are, in many cases, undertakings that require considerable intellectual and academic fortitude. It is understandable that fans of *Star Wars* might want to assist in elevating the languages of their favourite science-fiction franchise to the same level as that of *Star Trek*'s Klingon or Tolkien's various Elven dialects, and the fact that such development is possible lends greater authenticity to the various languages in question. As Traviss, writing on her website, says of Mando'a, 'Treat it like real languages – they also evolve daily and spawn different versions'. A language that cannot change, cannot grow, has ceased to function as a language at all. And as the individual languages that have emerged from the *Star Wars* universe continue to

Greater than the Sum of its Parts:
The Singular Emergent Language of the *Star Wars* Universe
Kris Jacobs

Fig. 5: *Tauntaun sleeping bag – less graphic than in Empire Strikes Back.*

evolve, they likewise contribute to the continuing evolution of that greater, multifaceted language of which each of them is only a part.

How, then, to describe this greater language, this universal language so unique to the *Star Wars* universe? It may begin with English, or Galactic Basic Standard as the fans have termed it, but that is merely a jumping off point, a foundation for all that has since been built upon it. English is to the greater language of *Star Wars* what Latin was to Italian or Spanish or French: a place to begin. Even as a starting point, the use of English is varied considerably throughout the films, incorporating at times British accents for the Imperial officers and some of the Jedi, Americanized speech for certain members of the Rebellion, Jar Jar Binks' strange dialect and, not least, Master Yoda's inverted sentence structures.

Even within the confines of that traditional English foundation, certain phrases now serve as clear signals that the language being utilized is actually the language of *Star Wars* despite what one's ears might otherwise suggest. 'May the Force be with you', 'I'm your father' and 'These are not the droids you're looking for' are each examples of English-sounding sentences that can likely never again be uttered without invoking precise images of that galaxy far, far away. An even less traditional use of the English foundation for this new language involves the employment of completely new words like 'nerf-herder', 'bantha', and others like 'Jedi', which has already been discussed at some length. These words sound English; they follow Standard English structures and sound patterns; but the nouns they refer to do not exist outside the *Star Wars* universe. To speak them, one must lapse into a totally different language.

From its English base, the language of *Star Wars* expands to include all the other non-English and alien languages spoken by the characters in the books and films. Huttese, Ewok, Gungan, Twi'leki and all the many others appear in various levels of development. Some, like Ewokese, are derived from other Earth-based languages. Sullustan, the language spoken by Lando Calrissian's co-pilot during the Battle of Endor, was based on a Kenyan dialect called Haya. Others simply borrow certain phrases from existing languages. During the podrace in *The Phantom Menace* (Lucas, 1999), Watto and Sebulba shout 'Thank you' and 'You're welcome' to each other in Finnish at the end of the first lap of racing. But whether a word or phrase is invented, borrowed or stolen outright, fans of the saga seem to have no trouble with the requisite translation. Bib Fortuna's stern '*Nudd chaa!*' in the halls of Jabba's palace, Wickett's endearing '*Yub-yub!*' in the forest of Endor, or any one of Chewy's howls, grunts and growls are all met with an equal understanding.

When these many spoken words, the familiar and the alien alike, are combined with the myriad sounds indigenous to this universe – the firing of a blaster, the menacing chuckle of a Hutt, the buzzing crash of two lightsabers colliding – the end result is what we've been striving after this whole time: a fully formed, expressive, communicative, continually evolving language, uniquely capable of describing the universe from which it originates.

If this seems like too big a stretch, if it seems too far-fetched to consider a squeak from an R2 unit as a small piece of a greater linguistic puzzle, consider your own modes of communication. In speaking with one another we use so much more than mere words. A conversation between two humans includes gestures, strange sounds and facial expressions every bit as much as it uses vocabulary. These extra ingredients make it easier for us to express ourselves; they enhance the abilities of our language because they are a part of our language – in precisely the same way the sound effects, fragments of other languages and newly created words help make up the greater language spoken throughout the *Star Wars* universe.

If there remains any doubt that the universe George Lucas has created communicates with its fans in anything other than its own unique language, if there remains any doubt that the fans communicate with one another in that same language, perhaps it is appropriate to turn to C-3PO himself as the final example. Master translator, a protocol droid fluent in over 6 million different forms of communication, 'Threepio' could have told the Ewoks his story in their own language and been done with it. Instead, he utilizes the very language I've been describing. The droid blends a little Ewok, a little Galactic Basic, and a lot of clearly recognizable sound effects with the result that the Ewoks, the gathered heroes, and I daresay the audience of the film, become completely entranced. He uses a greater language to express himself in a way that no mere telling could ever do. It is a language that emanates from the universe at the same time as it describes it. It is a language that *Star Wars* fans understand implicitly whether they realize it or not. It is the greater language that unites us all. ●

GO FURTHER

Books

Culture, Identities, and Technology in the Star Wars Films: Essays on the Two Trilogies
Carl Silvio and Tony M. Vinci (eds)
(Jefferson: McFarland, 2007)

Finding the Force of the Star Wars Franchise: Fans, Merchandise, and Critics
Matthew Wilhelm Kapell and John Shelton Lawrence
(New York: Peter Lang, 2006)

Star Wars on Trial: Science Fiction and Fantasy Writers Debate the Most Popular Science Fiction Films of All Time
David Brin and Matthew Woodring Stover (eds)
(Dallas: Benbella, 2006)

Greater than the Sum of its Parts:
The Singular Emergent Language of the *Star Wars* Universe
Kris Jacobs

Using the Force: Creativity, Community, and Star Wars Fans
Will Brooker
(New York: Continuum, 2002)

The New Oxford American Dictionary
Elizabeth J. Jewell and Frank Abate (eds)
(New York: Oxford, 2001)

*The Science of Star Wars: An Astrophysicist's Independent Examination of Space Travel,
Aliens, Planets, and Robots as Portrayed in the Star Wars Films and Books*
Jeanne Cavelos
(New York: St. Martin's, 1999)

Star Wars: The Magic of Myth
Mary Henderson
(New York: Bantam, 1997)

Star Wars: The Movie Trilogy Sourcebook
Peter Schweighofer, Bill Smith, and Ed Stark (eds)
(Honesdale, PA: West End Games, 1993)

Extracts/Essays/Articles

'Skxawng!'
Ben Zimmer
In *New York Times*, 4 December 2009,
Available at: http://www.nytimes.com/2009/12/06/magazine/06FOB-onlanguage-t.html?_r=1

'The Sound Mind of Ben Burtt'
At 'Studio 360', 20 February 2009, http://www.studio360.org/2009/feb/20/the-
sound-mind-of-ben-burtt/

'WALL-E, Waterfalls, Batman'
At 'Studio 360', 27 June 2008,
http://www.studio360.org/2008/jun/27/

'Racial Ventriloquism'
Patricia J. Williams
In *The Nation*, 5 July 1999,
Available at: http://www.thenation.com/article/racial-ventriloquism

'Ben Burtt'
John Papageorge
At 'Silicon Valley Radio', http://www.transmitmedia.com/svr/vault/burtt/index.html

Websites

Allwords.com', http://www.allwords.com/word-jedi.html

'The Complete Wermo's Guide to Huttese (and other *Star Wars* languages)', http://www.completewermosguide.com/index.html

'Designing Sound', http://designingsound.org/tag/ben-burtt-special/

'Film Sound.org', http://filmsound.org/starwars/

'The Internet Movie Database', http://www.imdb.com/title/tt0076759/trivia

'The Jedi Sanctuary', http://web.archive.org/web/20070630060055/http://www.jedisanctuary.org/history.php

'Lard Biscuit', http://www.lardbiscuit.com/jidaigeki/intro5.html

'Karen Traviss', http://www.karentraviss.com/page20/page26/index.html

'Wookieepedia', http://starwars.wikia.com/wiki/Main_Page

Chapter
8

Star Wars Generations – A Saga for the Ages, for All Ages

Brendan Cook

→ **NOT TOO LONG AGO, IN A MOVIE THEATRE FAR, FAR AWAY...**
She was going on her first date; her date had picked the movie but picked the one she would have chosen. It was hard to tell who was more excited, the young teens on their first date, or her father. After all, she was as geeky as he was, and a boy who would pick *Star Wars Episode I: The Phantom Menace*, in *3D* - well, he couldn't be all bad.

Fig. 1:
Loews Astor Plaza, 1983.

It is difficult to get a grasp on the breadth and depth of the legacy which George Lucas has created, or how it has transcended generations. Rather than casting about for things which can anecdotally shine light on the impact of Lucas' work, a more objective measure is required. For that, we can turn to a tool often relied upon by historians: capitalism. Some of the earliest records which provide us insight into cultures long gone from the face of the planet are commercial records, such as those ancient Mesopotamian commodity tokens which led to the development of cuneiform. Insight into the impact of *Star Wars*, and its continuing impact, can be gleaned by looking at the things it has produced and the money that it has generated. Certainly one need not look far today to come upon a licensed *Star Wars* product, from action figures, toys, video games, books, bobblehead dolls, plush dolls, titanium die-cast ship models, posters, and perhaps even some little something available through your local drive-thru window. However, the ubiquity of the *Star Wars* merchandise hardly tells the tale that began in the mind of George Lucas in 1973 and exploded onto the silver screen four years later.

And explode it did. *Star Wars*, now known as *Star Wars Episode IV: A New Hope*, brought in more than $1.5 million on its limited opening weekend in May 1977, and added another $6.8 million in its wide opening weekend in July, according to movie site boxofficemojo.com. Since opening in limited release on 25 May 1977, *Star Wars* has brought in $461 million domestically, plus another $314 million in foreign release. It is difficult to fathom, but the film that studios thought was incredibly expensive to produce, with a cost of $11 million, has brought in more than $775 million dollars, a rate of return which is nothing short of phenomenal.

The epic story Lucas brought to the screen in *Star Wars* captivated audiences, so it was little wonder that when *The Empire Strikes Back* (Kreshner, 1980) opened in limited release on 21 May 1980, it brought in $4.9 million. A month later, on 20 June, the film opened in wide release and brought in another $10.8 million dollars. In the ensuing 32 years, the second instalment of Lucas's saga has earned $538.4 million. By the third instalment, the adventures of Luke, Han, Leia, Chewbacca and the droids had earned the right to open directly into wide release, in over 1000 theatres, with weekend earnings of over $23 million. When taken together with *Return of the Jedi's* (Marquand, 1983) worldwide gross of $475.1 million since its release, the Original Trilogy (OT) have earned a combined $1.79 billion in revenue and, when adjusted for inflation, this number almost doubles to $3.3 billion.

Lucas, however, was not content to rest on his laurels, nor was he content to leave the story where it was. The sweeping saga brought to the screen in his three original

Star Wars **Generations –**
A Saga for the Ages, for All Ages
Brendan Cook

films comprised only a portion of the tale woven in Lucas's fertile imagination. In his book, *The Secret History of Star Wars*, Michael Kaminski writes that Lucas had planned to expand the story, both forward and backward through time, but lost interest in doing the sequels after suffering through a tremendously messy and expensive divorce in 1987. He notes, however, that Lucas remained interested in the already well-developed prequels. In 1994, Lucas began work on the screenplay that was to become *The Phantom Menace* (Lucas, 1999) (hereafter, *TPM*), and would mark the start of the saga of Anakin Skywalker, from his childhood to his death in the arms of his Jedi son.

The Prequel Trilogy (PT) was released between 1999 and 2005, with multiple films in various stages of production simultaneously. In his 2005 book *The Making of Star Wars Episode III – Revenge of the Sith*, Jonathan Rinzler writes that Lucas was working steadily on *ROTS* (Lucas, 2005) even prior to the theatrical release of *Episode II – Attack of the Clones*. These films were intended to appeal to the young fans of the trilogy, now grown and perhaps with children who might become the latest generation of young *Star Wars* fans. Lucas did not miss the mark, with *TPM* topping the box office on opening weekend with $64.8 million dollars. The film has gone on to earn a worldwide gross of $1.03 billion in the last thirteen years.

Despite launching the new trilogy like an overpowered podracer, the ensuing films failed to perform at the same level. Whether due to disenchantment by some of the loyal OT fans who frowned on the slick new films and their reliance on CGI effects and digitally-created shots, or simply a distaste for clearly marketing-oriented characters such as Jar Jar Binks, or some other factors, *ATOTC* (Lucas, 2002) and *ROTS* earned only about 65 per cent and 85 per cent as much as the *TPM*. When taken together, the prequels earned a worldwide box office of $2.52 billion. All told, the six films of the *Star Wars* saga have earned a box office total of nearly $4.4 billion, without adjusting for inflation, or approximately the 2011 Gross Domestic Product of Barbados.

Ever mindful of the aging of his first generation of fans, and even of his second generation of fans, Lucas brought a product to the market making it easy to introduce the newest generation of fans to the epic battle between good and evil. This took the form of a Cartoon Network 'microseries' in 2003, called *Star Wars: The Clone Wars*, which led to the CGI film of the same name and a longer-running cartoon series, also called *Star Wars: The Clone Wars*, which began to air in 2008. Key characters like Anakin and Obi-Wan were fleshed out, and the relatively high amount of screen time available through the vehicle of an animated series allowed the younger viewers to connect with them in ways not possible during a pitched battle against General Grievous in *ROTS*, for example. Further, characters such as clone troopers, who were literally one of millions, became identifiable and relatable. After all, not one but two clone troopers – Captain Rex and Commander Cody – made Mania.com's Top 100 *Star Wars* Action Figures list.

Turning the page

His bookshelves contained numerous examples of the literature created for the Star Wars *universe, while his sons' shelves contained more child-friendly tomes recounting the adventures of various heroes and villains in the Lego* Star Wars *world. His daughter, meanwhile had an e-book reader which held several of the shorter 'singles', all about the dawn of the Sith.*

The *Star Wars* saga may occupy a unique position among the many sagas of the world, in that it has successfully jumped the medium gap, but done so in an order which runs counter to the normal progression from literature to film. The first broad scope encounter with the saga was with Episode IV, though a novelization of the film was released in 1976. Lucas' universe began to expand almost immediately, with Del Rey's release of *Splinter of the Mind's Eye*, written by Alan Dean Foster – who was the ghost-writer of the aforementioned novelization. This literary expansion of the saga beyond the confines of the films has continued virtually unabated for the last 35 years. The flow of the licensed and authorized fiction has not been smooth and steady. There was significant output during the heyday of the OT, but it waned until the early 1990s. In 1991, Timothy Zahn published the first book in the Thrawn trilogy, *Heir to the Empire*, which seemed to reignite an interest in the films. The trilogy's popularity was not short-lived, and the book still placed in National Public Radio's Top 100 Science-Fiction, Fantasy Book, which were voted on by 60,000 fans of the genres.

The success of Zahn's trilogy no doubt prompted Lucas to push forward with his plans for the prequels, and also served to whet the appetites of fans for the next trilogy of films. Those appetites were also fuelled by the release by Dark Horse Comics of a series of graphic novels which served as sequels to the original trilogy. Dark Horse's efforts began, according to the company's official timeline, with the acquisition of the *Star Wars* license in 1991, coinciding with Zahn's efforts, and the works no doubt fed into each other's popularity. But bringing the *Star Wars* universe to fans from the pages of comics was hardly unique to Dark Horse. It began almost simultaneously with the release of the films, with comics published by Marvel Comics, and continued with the publication of newspaper comic strip produced by the Los Angeles Times Newspaper Syndicate. Dark Horse rekindled the comic book approach with the publication of *Star Wars: Dark Empire #1* in December of 1991.

Dark Horse continued publishing adaptations of the movies and stand-alone *Star Wars* stories and series, which continued to be popular. An indication of that popularity is that the company devoted the resources needed to create a brand new, 'never before seen' comic for the first industry-wide Free Comic Book Day in 2002, and distributed 400,000 copies of that specially-created book to comic stores nationwide. The publisher's adaptation of the third film of the PT, *Star Wars Episode III: The Revenge of the Sith*, achieved a level of popularity significant enough to hold a top 10 position in Nielsen Bookscan's Top 50 rating in 2005. The publisher has continued to print adaptations

Star Wars Generations –
A Saga for the Ages, for All Ages
Brendan Cook

and expansion, create tie-ins with toy maker Hasbro, and even released an online-only comic series in February 2009, called *Star Wars: The Old Republic – Threat of Peace*.

The market for stories from the *Star Wars* universe – be they part of the OT, the PT or part of the Expanded Universe, which has grown to fill the millennia before the OT, the years between the films we have seen, and the years after – continues to thrive. Over the last four decades, more than 275 novels and novellas have been published, not to mention nearly 80 different reference books that allow fans to dig deeper into the saga and learn how the films were made, how to identify the myriad ships, vehicles and creatures in film and print, and even take a look inside vehicles brought to life on-screen by the designers at Industrial Light and Magic and Lucasfilm.

It would be easy to ascribe this kind of catalogue to the longevity and success of the film franchise – that, naturally, over the course of nearly 40 years, numerous books would be published for readers, young and old alike to enjoy, when not watching their favourite instalments of the saga. However, it is worth noting that the appeal of the saga, and its impact, are not limited simply to stories which flesh out the universe Lucas first presented to us; rather the epic has even entered into the realm of spiritually-oriented writings, as already discussed in greater length in Chapter 7. These include such texts as: *The Dharma of Star Wars*, by Matthew Bortolin; *The Gospel According to Star Wars: Faith, Hope and the Force*, by John C. McDowell; *Finding a God in a Galaxy Far, Far Away: A Spiritual Exploration of the Star Wars Saga*, by Timothy Paul Jones; *Wizards, Wardrobes and Wookies: Navigating Good and Evil in Harry Potter, Narnia and Star Wars*, by Connie Neal; *The Jedi in the Lotus: Star Wars and the Hindu Tradition*, by Steven J. Rosen and Jonathan Young; *The Power of the Force: The Spirituality of the 'Star Wars' Films*, by David Wilkinson; and *The Tao of Star Wars*, by John M. Porter. These spiritual texts are not oriented solely at the academics or those with a penchant for eastern spirituality; there are also texts with a decidedly Judeo-Christian bent as well, such as *Christian Wisdom of the Jedi Masters*, by Dick Staub and even a *Connect Bible Studies* edition based on the *Star Wars* trilogy.

Playing amongst the stars

How many hours were wiled away in his college days, strapped into the virtual cockpit of an X-wing fighter, spinning, diving and fighting through space to complete his missions and earn the appropriate ribbons, medals and recognitions needed to advance. Or later, on the pilot's couch in a Seinar Fleet Systems TIE Fighter, striving to stay alive without any shielding or hyperdrive to facilitate a quick escape from the maelstrom. The question of a new game for their Xbox 360 Kinect was raised, and his daughter wondered if it was such a good idea to have the boys learning lightsaber combat with the Kinect, given how much time was spent breaking up dangerous lightsaber duels as it was. The young teen makes a good point, but still...it's lightsabers!

With films to watch in theatres, as well as books and comics to read, what more could

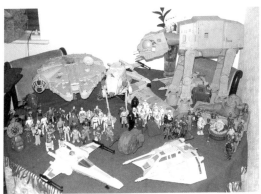

Fig. 3:
A commendable collection
Olly-K: photobucket.com.

Fig. 4:
www.starwarstoymuseum.
com.

generations of *Star Wars* fan want? To be a part of the story, to participate in the adventures rather than simply consume them – and who is George Lucas to deny his fans? As explicitly discussed in Chapter 5, starting in 1982, video games based on the franchise were released, allowing fans to get their hands on the story, or at least a part of it, in a very literal way. And that participation has been a key component in the continuity of the *Star Wars* phenomenon through a few generations. Let us now look at those games in a little more detail to see how, exactly, the video games captivated various ages of *Star Wars* fans...

The first video game published was *The Empire Strikes Back*, by Parker Bros., which was released for the Atari 2600 console. The game put players behind the controls of a snowspeeder on Hoth, tasked with defending the Rebel base from the attacking Imperial troops and destroying AT-AT walkers. The following year saw the release of a game tied to *ROTJ*, entitled *Return of the Jedi: Death Star Battle*, which put the fans at the helm of Han Solo's Millennium Falcon with a mission to destroy the second Death Star at the Battle of Endor. *Jedi Arena* was also released that year; the Parker Bros. game was based in large measure on the scene in Episode IV when Luke engages in lightsaber training against a remote, and marked the first attempt to allow fans to partake in that very Jedi privilege: wielding a lightsaber.

Star Wars games moved out of the home and into the arcades in 1983, with the films' fans dropping quarter after quarter into Atari's *Star Wars Arcade*, which put the player in the role of Luke Skywalker in the attack on the Death Star at the Battle of Yavin. This game was followed shortly by the sequel, *The Empire Strikes Back*, which was based on the same vector-graphic technology. Conversions were made available to allow video arcade operators to upgrade the games to the latest instalment in the series and keep fans interested, engaged and happily parting with their quarters.

The early 1990s saw the return of the *Star Wars* video game to the home, and even to the portable gaming console. In 1991, *Star Wars* was released for the Nintendo Entertainment System (NES), the Game Boy, Sega Game Gear and the Sega Master System, with *Star Wars: The Empire Strikes Back* following a year later. Given the pace at which Lucasfilm licensed *Star Wars* and produced tie-ins and expansions to the universe, one might expect that the pace of video game production might have matched up well, but the truth is just the opposite. In fact, when compared to the production of toys and memorabilia, or the publication of books related to or expanding the *Star Wars* universe, gaming opportunities barely kept pace. This is not to say, however, that Lucasfilm did

Star Wars **Generations –**
A Saga for the Ages, for All Ages
Brendan Cook

not capitalize on the broader adoption of both the personal computer and the console gaming system, or that the relatively sedate pace would continue.

The first game to focus on the Expanded Universe, rather than strictly the film plotlines, was *Star Wars: X-Wing*, which put the player in the role of a Rebel Alliance starfighter pilot, and put the player directly into the pilot's seat. The goal was to complete a variety of missions against the Empire, while engaging in point-of-view (POV) dogfights in three dimensional space, managing weapons and shielding, while coordinating with wingmen and teammates to achieve various mission objectives. This 1993 release was followed in relatively short order by *Star Wars: TIE Fighter*, which picks up the narrative from roughly shortly after the Battle of Hoth. Instead of fighting the Empire, the player is fighting for the Empire, and begins by flying the eponymous ball-cockpit TIE fighter; successful missions allow the player to earn the right to fly TIE Interceptors, TIE bombers, TIE Advanced and Assault Gunboats.

The third game in this sequence was *Star Wars: X-wing vs. TIE Fighter* (hereafter, *XvT*), which unsurprisingly allows players to play through the same sequence of missions from either perspective, and is the first foray into the multiplayer realm for Lucasfilm. However, the lack of a storyline in the game had negative repercussions in terms of popularity, this despite the fact that the game would allow up to eight players and each could customize their fighters rather heavily. The lack of the same kind of fan appreciation the other games had garnered prompted Totally Games to release the *Balance of Power* expansion pack, which added a fifteen-mission storyline complete with the cutscenes the game originally lacked. This expansion was well received by fans, and the technological achievement of the game should not be overlooked. While other multiplayer shooter games such as *Doom* (Software, 1993) and *Descent* (Interplay, 1995) were available and popular at the time, *XvT* was the only multiplayer game that maintained full information regarding the positions and actions of all eight players simultaneously, and made it fully available – and often visible – to each of the player, all while operating in a simulated three-dimensional deep space environment.

The final year of the century saw the release of the first film in the saga and the first instalment of the PT, as well as the fourth and final game in the series, entitled *Star Wars: X-Wing Alliance*. The game took players into things never before experienced. The extended storyline allowed players to take on the roles of several characters, complete multi-stage missions, which involved hyperspace jumps from one place to another, and even participate in the Battle of Endor. In addition, players were able to pilot their fighters into starship hangar bays in order to be repaired or rearmed. Another feature this game added was allowing the player to pilot multi-crew ships such as the Millennium Falcon, or to man either the dorsal or ventral turret while the game's artificial intelligence took on whatever roles the player declined. Perhaps the most exciting feature was the custom mission builder, which allowed players to set up custom missions involving virtually any spacecraft in the game and to fly craft which previously had been

enemy craft in other missions.

The release of *TPM* seemed to open the videogame floodgates, and the flow of games seems to have surged with each subsequent prequel release. These many games have encompassed a variety of video game genres, including: racing games, such as *Star Wars Episode I: Racer*, which focused on podracing; real-time strategy (RTS) games such as *Star Wars: Rebellion* and *Star Wars: Force Commander*; console games such as *Knights of the Old Republic* (which won video game of the year in 2003); and simulator games such as *Star Wars: Jedi Starfighter*. A recent LucasArts offering for the Microsoft Xbox game console, *Star Wars: The Force Unleashed 2*, set between *ROTS* and *ANH*, follows the story of Darth Vader and his apprentice, Starkiller. The game, a sequel to a game which sold over 7 million copies, allows for incredibly detailed interactions with the environment and non-player characters, as well as such advancements as giving the player the ability to wield dual lightsabers in combat. As noted in Chapter 5, and importantly to the continuity of the appeal of the franchise to different generations, these *Star Wars* games are not limited to those which appeal only to the more adult players; some of the best selling games bearing the *Star Wars* name are those belonging to the *Star Wars* Lego series. These games port the battle between light and dark sides of the Force, between the Jedi and the ominous Sith, into the child-friendly environs of stubby-legged, yellow-headed heroes and click-lock blocks.

The saga continues

It is difficult to precisely determine the cultural impact the *Star Wars* saga has had since its beginning simply because it means so many things to so many people around the world. There are purists who think that anything beyond the Original Trilogy diminishes the epic; there are those who will accept only the films and disavow the *Clone Wars* animated film and series, as well as the ill-fated *Holiday Special* (Binder and Acomba, 1978); and then there are those for whom all things are a part of the saga. To bring them all together into one coherent whole, we must look beyond each limited viewpoint and see what things are actually being produced and purchased to determine how the saga is impacting generations of fans.

This seemingly dispassionate examination of the impact of *Star Wars*, both in terms of the amount of money spent on it, as well as the sheer volume of products brought to market may seem to strip away some of the mystique and excitement Lucas brought to us, with the Jedi, and the Force, and epic battles between good and evil in a galaxy far, far away; but the truth is that it provides us the best window to examine, and a reasonable metric to assess, how these last few generations have been impacted by *Star Wars*. Children of the '90s and '00s can play *Star Wars* video games, wear *Star Wars* costumes for Halloween (sometimes even accompanying their similarly costumed parents), stage mock space battles with *Star Wars* fighter toys, make their own *Star Wars* adventures with the new generation of *Star Wars* action figures (or even re-issues of the original

Star Wars **Generations –**
A Saga for the Ages, for All Ages
Brendan Cook

Kenner models), and read about the fate of the Jedi and the galaxy after the death of the Emperor at the Battle of Endor. Their parents, looking on, will hearken back to the days when they did the same, and carried their lunches to school in a *Star Wars* lunch box, or slept on *Star Wars* sheets and woke to an alarm clock with C-3PO translating R2-D2's warble and urging the child to wake up.

Rather than a passing fancy, the saga has captured the hearts, minds and imaginations of millions and millions of fans, and their children and grandchildren in the last four decades. It is not overstating the case to say that the world was irrevocable changed in May of 1977. And, judging by the growth and popularity of the video games, action figures, toys, animated series, books, and even costuming organizations such as the 501st Legion, it is highly unlikely that the impact of the saga launched that fateful summer will end with this generation of fans. ●

GO FURTHER

Books

The Making of Star Wars Episode III – Revenge of the Sith
J.W. Rinzler
(New York: LucasBooks, 2005)

Extracts/Essays/Articles

'Top 100 Science Fiction Books'
John Clute, Farah Mendlesohn and Gary K. Wolfe
At *NPR*, 11 August 2011,
Available at: http://www.npr.org/2011/08/11/139085843/your-picks-top-100-science-fiction-fantasy-books

'Top 100 Star Wars Figures'
Rob Worley, Chris Beveridge and Richard Kura
At 'Demandmedia.com', 14 May 2010,
Available at: http://www.mania.com/top-100-star-wars-figures_article_122562.html

'From Luke to Anakin: Growing Up with *Star Wars*'
Scott Holleran
At 'Box Office Mojo', 18 May 2005,
Available at: http://www.scottholleran.com/old/movies/star-wars-luke-anakin.htm

Websites

'Alan Dean Foster', http://www.alandeanfoster.com/

'Amazon', http://amzn.to/10Euyc4

-----, http://amzn.to/15jQPwq

'Box Office Mojo', http://boxofficemojo.com/movies/?id=starwars3.htm

'Dark Horse', http://www.darkhorse.com/Company/Timeline

'I Love Comix', http://www.ilovecomixarchive.com/s/star-wars

'Ugo', http://www.ugo.com/games/star-wars-games

The Marketing of The Force: Fans, Media and the Economics of *Star Wars*

Neil Matthiessen

→ 'I'm retiring,' Lucas said. 'I'm moving away from the business, from the company, from all this kind of stuff'. In an interview with Bryan Curtis, after thirty-five years with *Star Wars*, George Lucas stated he is walking away. Still, no one expected his retirement to be accompanied with the $4 billion sale of the franchise to Disney. Was it that easy for Lucas to walk away from the *Star Wars* franchise, from the empire that he created that went on to become the phenomenon that it is today?

In an interview with *The New York Times*, conducted in conjunction of the US cinema release of *Red Tails* (Hemingway, 2012), a World War II drama, Lucas cites fans' negative reactions to his recent efforts in the release of *The Complete Saga in Blu-ray* on 16 September 2011. 'On the Internet, all those same guys that are complaining I made a change are *completely* changing the movie,' Lucas says, referring to fans who, like the dreaded studios, have done their own forcible re-edits. 'I'm saying: "Fine. But my movie, with my name on it, needs to be the way I want it"'.

Lucas has always had issues with fans and keeping to his vision of *Star Wars*, and this might have been the last upshot in the 35-year saga between Lucas and 'fans'. Though Howard Roffman, president of Lucas Licensing, stated in 2007, 'George has been pretty clear that he will not make another *Star Wars* movie that's based on the saga of the Skywalker family [...] It's conceivable that some of the things that we will do on television could brave some expression in a movie theater, but if we did that it would be more as a way of promoting the television'. Now all this has obviously changed with the release of Episode 7 looming in the near future (planned for 2015).

Star Wars has become a global empire, and the consumption of its artefacts is but one aspect of the scope of the franchise. If the survival of the *Star Wars* universe depended solely upon the marketing of the films' merchandise, the *Star Wars* franchise would have collapsed long ago and faded into childhood memories. That did not happen. *Star Wars* became twentieth-century mythology. According to Andrew Gordon:

Lucas created a myth for our times, fashioned out of bits and pieces of twentieth-century American popular mythology – old movies, science fiction, television, and comic books – but held together at its most basic level by the standard pattern of the adventures of a mythic hero. *Star Wars* is a masterpiece of synthesis, a triumph of American ingenuity and resourcefulness, demonstrating how the old may be made new again: Lucas raided the junkyards of our popular culture and rigged a working myth out of scrap [...] He lifted parts, openly and lovingly, from various popular culture genres, but the engine that runs it is the 'monomyth'.

Star Wars' survival and ongoing success depends upon the deep, mythological connections that fans have constructed. One can easily see these connections when compared to Joseph Campbell's *Four Functions of Myth*:

1. *The Mystical Function* – that which evokes a sense of awe in the individual.
2. *The Cosmological Function* – to present an image of the cosmos, an image of the universe round about, that will maintain and elicit this experience of awe and explain everything that one comes into contact with in the universe.
3. *The Sociological Function* – to validate and maintain a certain sociological system; a shared set of rights and wrongs, proprieties or improprieties, on which one's particular

The Marketing of The Force:
Fans, Media and the Economics of *Star Wars*
Neil Matthiessen

social unit depends for its existence.
4. *The Psychological Function* – the psychological. The myth must carry the individual through the stages of his life, from birth through maturity, through senility to death.

When comparing fans' reactions to the *Star Wars* saga, George Lucas as story-teller has, in fact, created a mythology that has developed a life of its own. In the book, *Using the Force: Creativity, Community and Star Wars Fans*, Brooker explores how *Star Wars* has affected and permeated viewers' lives. He further exemplifies this when he says, 'the films have been embraced by and incorporated into the lives of millions of viewers. On one level, *Star Wars* does not belong solely to Lucas anymore; its characters and stories have escaped the original text and grown up with the fans that have developed their own very firm ideas of what *Star Wars* is and is not about'. This is, simultaneously, a blessing and a curse to the franchise. On the one hand, the success of the *Star Wars* franchise relies on these fans; yet, at the same time, it is these same fans who have dedicated their lives to the protection of the mythos and even their belief system. *Star Wars* is a brand; a brand that encompasses emotions, thoughts, images, history and possibilities. One could even say that 'brand', in this case, mirrors mythology. A strong relationship with a brand needs to exist for the consumer. Arguably, however, a difference between mythology and brand can exist, depending upon the observer. Lucasfilm sees *Star Wars* as a 'brand' due to its monetary value, which amounts to billions. But to the fans, it is simply a mythology. There is no monetary value; it is the mythos that intrigues and engages. The result is a universe divided – one side protecting the money-making market entity, and the other guarding the legend that is *Star Wars*.

Star Wars: the business
The empire that George Lucas created, beginning with his first movie, *Star Wars* (Lucas, 1977), released on 25 May 1977, has morphed into a complex machine with a profit of over $20 billion in consumer sales worldwide. As chapters throughout this book have explicitly illustrated, no longer is the *Star Wars* franchise just about that which is shown on a movie screen, according to the licensing website; rather, it also includes merchandise that is sold in over 100 countries and includes an extensive toy line, 100 million books in print, apparel, consumer electronics, housewares, and an extensive collection of interactive entertainment titles.

Considering the extent of the global *Star Wars* phenomenon, it seems perplexing that in fact, in 1985, the fanbase dwindled after *Return of the Jedi* (Marquand, 1983), and the franchise almost collapsed. With no new movies being released, *Star Wars* was losing its fans. The saga was becoming a fading memory; *Star Wars* was slowly being replaced. The late 1980s through the early 1990s was a trying time for the *Star Wars* franchise. Without any new films to focus on, the fans started to turn on each other. Then there came the point when even hateful fan letters stopped; the fans had nothing

to say. Nowakowska summarizes these years best:

There were some dark years ahead as SW fandom came to terms with the irreconcilable differences that existed among its members. Differences of opinion seemed to automatically transform into accusations. Sarcastic 'how could you possibly believe that..'. comments escalated into personal attacks on the opposing fan's moral judgments. The word 'fascist' had been used before to deride arguments in favor [sic] of the Imperials, but now fans were accused of such attitudes simply because they disagreed with another fan's opinion. As mentioned earlier, fandom finally got angry enough to engage its most powerful defense [sic]: shunning. The instigators of the worst hostility found their letters were ignored; received and printed, yes, but no one responded. The topics and conversations flowed on around them without the slightest indication that their hostility mattered to anyone. And, eventually, those hateful letters stopped coming to the editor. Unlike other products, the entertainment industry as a commodity must continually deliver something new in order to keep interest alive. Lucasfilm referred to this period as the 'dormant' period: Things really hit rock bottom. I engaged a number of consultants and we did all kinds of studies looking at how we could bring Star Wars back and it just became clear that it would be a mistake to bring it back at that point. There wasn't any interest at retail [...] George was very philosophical about it. Lisante states that he basically said, 'it's good to let it rest'.

During this dormant period in the late 1980s, the franchise continued to invest in the development of new content to recapture the original fans and to attract a new generation. The Star Wars franchise started to adopt a new marketing strategy unlike the first one with a 'simple business philosophy: stay focused on key merchandise categories – toys, publishing, video games, and collectables'. This model works only when the consumer stays interested, but consumers – even niche consumers – can be fickle. Companies often continue to produce as they always have, with little regard to what buyers actually want. Palmer states that 'At best, they may have a poor understanding of the complex needs that buyers seek to satisfy, and may have little idea about how these may change over time'. However, George Lucas and his companies behind the Star Wars franchise began to realize that new strategies were needed, beginning with being more responsive to the fans. Howard Roffman, president of Lucas Licensing explains: We started looking at a new strategy of introducing new products that would be of interest to the original Star Wars kids at this new point in their lives [...] most of them were college-age or young adults; we thought the best area to experiment in was publishing. We believed we could deliver news stories set in Star Wars Universe and take the characters beyond where they went in the films. (The Star Wars Phenomena)

As discussed in greater detail in Chapter 9, this new direction led to the Heir to the Empire which was published in 1991 and spent 29 weeks combined on The New York Times

The Marketing of The Force:
Fans, Media and the Economics of *Star Wars*
Neil Matthiessen

paperback and hardback best-seller lists. 'No one knew how well they would do,' author Timothy Zahn said. 'The fans had nothing much to grab on to until the books came out'.

In the same year, Lucasfilm licensed with Dark Horse Comics, a six-issue bimonthly, and produced *Dark Empire*. Lucasfilm was now successfully getting the original fanbase energized. To commemorate the twentieth anniversary of the release of *A New Hope*, the special edition of *Star Wars* was released in 1997 and the related toys became the number one boys' toy line once again. The growth continued to skyrocket as the prequels were released in 1999, 2002 and 2005 (all dir. George Lucas). During this time period, Lucasfilm was also researching other avenues for the expansion of its fanbase beyond theatrical films and publishing.

To continue the growth of the *Star Wars* franchise, and to keep fans engaged, Lucas turned to two new focus areas: television and video games. The animated feature, *Star Wars: The Clone Wars* was released on 15 August 2008 as an introduction to *Star Wars: The Clone Wars* television series that debuted on Cartoon Network on 3 October 2008. The *Star Wars* franchise heavily targeted the video game industry, the development of which – regarding *Star Wars* – has already been discussed in this book. As Roffman explains, 'video games are an indispensable way of engaging people today. People spend two hours at a movie theater watching a movie, but with a video game, they are spending 10, 20, 30 hours'. Television and video games were nothing new to the *Star Wars* franchise, however. During the first three trilogies, video games and a TV series were created. With the release of the original three trilogies and the prequels, it was almost *déjà vu*. So why has *Star Wars* not suffered the same fate of dwindling interests this time around, but instead has firmly rooted itself into popular culture? The franchise, according to Palmer, started 'to understand and respond to customers' needs and the necessity to search constantly for new market opportunities. In a truly marketing-oriented organization, these values are instilled in all employees and should influence their behavior [sic] without any need for prompting'. George Lucas started to embrace the fans instead of fighting them; Lucasfilm looked to the fans to help the franchise. This was not an easy task to take, even though fans are a major part of the *Star Wars* experience, as a company, focus has to be made on the profitability. Listening to the fans has to be balanced, as a marketing-oriented organization, the *Star Wars* franchise can only exist and to continue to exist if it meets its own objectives. This means it is able to continue to make a profit, and Disney is banking on this to an unforeseeable future.

At the same time that Lucasfilm was re-releasing the Original Trilogy as Special Editions, the Internet was taking hold in society. This, along with the new marketing strategy, helped to return *Star Wars* to its cultural heyday. Lucas Licensing's revival of the franchise was a calculated and well-executed plan, but could easily have resulted in the waning fanbase era of years past. Star Wars could have simply become a cult; a story kept alive by its fans. Instead, it continued to produce new products worldwide and developed new fans through these ventures. Most importantly, however, it now really

became integrated into culture; it is the 'brand' customers purchased to experience the story. Explaining the importance of active consumption – participation – which numerous previous chapters have shown to be at the heart of the success of the *Star Wars* franchise, Holt states: The product is simply a conduit through which costumers can experience the stories that the brand tells. The fans must be able to buy into the myth; there are many products that are interwoven into the fabric of popular culture that do just this. Eventually, however, the fans are going to want to participate in the story; it is not necessarily enough for them to simply buy into the experience.

It is this participation that helps drive *Star Wars* industries, but also fuels conflicts between the creator, George Lucas, and the fans.

With the Internet in its infancy, no one knew exactly what its true impact would be. And just as fans could gain access to other fans' works and insights through a variety of media, so could Lucasfilm. They quickly realized that anyone could create a website and, that as a company, they had a brand to protect, but this has caused a backlash from the fans according to Brooker:

There has been quite a bit of confusion on the internet regarding Lucasfilm's position on Janson Rupini's web page. Please let us clarify. First and foremost, we are not 'shutting down' Jason's website. We are sorry for any confusion that may have emerged from any miscommunication on our part. Lucasfilm appreciate *Star Wars'* fans support and we want to be able to communicate with one another. Your energy and enthusiasm makes you an important part of our *Star Wars* family. As you can understand it is important as well for Lucasfilm to protect the *Star Wars* copyrights and trademarks since the Internet is growing so fast. We are in the process of developing guidelines for how we can enhance the ability of *Star Wars* fans to communicate with each other without infringing on *Star Wars'* copyrights and trademarks and we hope to make these guidelines available in the near future. As we prepare for the *Star Wars Trilogy Special Edition*, which will be coming to theaters [sic] next year, and as we begin pre-production on the upcoming prequels, we are now entering an exciting new star where is there a many thanks for your support and interest.

Not only do positive words get around quickly on the Internet, so does negative publicity. As explained in Chapter 4, fans felt that Lucasfilm was going after their sites, even though it was a company policy since 1981 that 'the company tolerates the publication of fan fiction, so long as the stories are not for commercial gain and don't sully the "family" image of the Star Wars characters'. As Lucasfilm spokesperson Jeanne Cole stated, 'What can you do? How can you control it? As we look at it, we appreciate the fans, and what would we do without them? If we anger them, what's the point?' Lucasfilm had to find the balance between a happy fanbase, while still protecting the franchise's interests.

The Marketing of The Force:
Fans, Media and the Economics of *Star Wars*
Neil Matthiessen

Star Wars no longer belongs to George Lucas, but he is still the father of the saga
The fans are an integral part of the *Star Wars* experience, yet if the franchise only listened to the existing fans, new fans would never be attracted. In fan culture, there will always be a fraction of fans with different opinions and viewpoints. Matt Hills looks at this issue – here he argues if one segment of fandom had its way, then new and creative variations would not exist:

[F]andom loses any possibility of creative textual mutation and thus becomes locked into its rigidly maintained sets of value, authenticities, textual hierarchies and continuities [...] had the comic fans' agenda been allowed to dictate the 'good' Batman and thus allow the 60s TV program, or the Burton and Schumacher films, then the character of Batman would be unlikely to retain the resonance and cultural hold which it continues to possess within contemporary culture.

This could not be any more evident than during the release of *Star Wars Episode I: The Phantom Menace* on 19 May 1999. The original *Star Wars* fans felt that they had been betrayed. Webmaster, Kolnack, of the Clone Wars unofficial fansite, complains in an open letter to Lucas:

Much of the movie was too influenced by marketing [...] the movie should have had us, (the die-hard fans), in mind more than it did and we all know that. George Lucas should have consulted with us, the fans, as to what we think and what we'd be most excited to see in this film [...] [We] hope he doesn't repeat the same mistakes twice. Make this one for us, George; after all, it's fans like us who've made you and your family millionaires many times over!

As this open letter to Lucas rightly points out, the *Star Wars Episode I: The Phantom Menace* was influenced by the market, but the market was not the original fans. Lucas made it no secret that the prequels where intended for 12-year-old boys. If Lucas and Lucasfilm had kept and tailored the prequels to the original fans, then Lucasfilm would not have captured a whole new generation of *Star Wars* fans. Going back to the idea of mythology, an argument could be made that the story that George Lucas made is larger than him and has become a mythology. A strong case can be made for this, but modern day mythology does not go very well with current copyright and trademark laws. *Star Wars* as a mythology is very powerful. Wendy Gordon examines the power of creative work in our modern society and its profound effect on people:

[M]any of our society's premiere creative works affect society in such a profoundly psychological way that they become 'part of' an individual. When that happens, the individual begins to think that 'if I cannot use [these works], I feel I am cut off from part of

myself. I would prefer never to have been exposed to them rather than to experience that sort of alienation'. Additionally, in today's omnipresent media culture, individuals are constantly subconsciously bombarded with a wide array of cultural artifacts [sic], and many times the individual will have no way of knowing in advance how these will affect her. If an individual is deeply moved by a cultural artefact [sic], so much so that the individual feels drawn to create a new worked based on the old, then that individual would be harmed if copyright law forbids it.

This is the very heart of the issue of fandom: the fans are so moved by the stories that they are compelled to become a part of the story, either by creating their own works or even becoming the characters themselves; they have become the canon that is *Star Wars*. Simultaneously, this idea that one is so connected to the story allows fans to become immersed into the story and make it their own. Consider Elana Shefrin's theory that 'consumers may believe that they are operating with free choice when, in fact, they are generally unable to change any of the cultural products being offered—their only choices are acceptance or rejection'. This may be the situation that fans of *Star Wars* face currently, that they really have no input to the story and that they are mere consumers. As an economic representation (this model of façade ownership), the fans preserve what they are contributing to the story and the universe, when, in reality, they are only extras in someone else's universe. But it is these extras that are vital to the continuation of the *Star Wars* empire. ●

GO FURTHER

Books

Introduction to Marketing Theory and Practice
Adrian Palmer
(Oxford: Oxford University Press, 2012)

How Brands Became Icons: The Principles of Cultural Branding
Douglas B. Holt
(Harvard Business Review Press, 2004)

Pathways to Bliss: Mythology and Personal Transformation
Joseph Campbell
(New World Library, 2004)

The Marketing of The Force:
Fans, Media and the Economics of *Star Wars*
Neil Matthiessen

Hey Whipple Squeeze This: A guide to great ads
Luke Sullivan
(Wiley-Blackwell, 2003)

Fan Cultures
Matt Hills
(New York, Routledge, 2002)

Using the Force: Creativity Community and Star Wars Fans
Will Brooker
(New York & London, Continuum, 2002)

Extracts/Essays/Articles

George Lucas is ready to roll the credits
Bryant Curtis
In *New York Times* magazine, 17 January 2012

The Incomparable Jundland Wastes
Maggie N. Nowakowska
At 'Falore.org', 2009,
Available at: http://fanlore.org/w/images/b/ba/JundlandWastes-rollup_2009-1.pdf

'The Star Wars Phenomenon'
Tony Lisanti
In *License Mag: Star Wars Anniversary Tribute*, September 2007,
Available at: http://www.licensemag.com/licensemag/data/articlestandard//licensemag/362007/455398/article.pdf

Some Realism About the Free Speech Critique of Copyright
David McGowan
In *Fordham Law Review* (vol.74, issue 2), 2005.

Lord of the Rings, Star Wars, and Participatory Fandom: Mapping New Congruencies between the Internet and Media Entertainment Culture
Elana Shefrin
In *Critical Studies in Media Communication* (vol. 21, no. 3), September 2004, pp. 261–81.

Novel force of 'Star Wars' Spinoffs: A galaxy of books employ characters and subplots of the popular movie trilogy and build on them for loyal fans
Tamara Ikenberg
In *The Baltimore Sun*, 9 September 1998, Available at: http://articles.baltimoresun.com

'Cyber Rights Now: "Scotty Beam Down the Lawyers!"'
Jennifer Granick
At *Wired*, 10 September 1997,
Available at: http://www.wired.com/politics/law/news/1997/10/7564

Star Wars: A myth for our time
Andrew Gordon
Literature and Film Quarterly, Fall 1978, pp. 314–26.

Websites

'Dark Horse', http://darkhorse.com/company/timeline

'Lucas Film', www.lucasfilm.com/division/licensing

Chapter
10

The Influence
of The Force

Jason Davis and Larry Pakowski

→ By now, consumers of popular culture are well aware that the term *Star Wars* no longer refers only to the series of films that have so captivated audiences since *A New Hope* (Lucas, 1977) had its big screen debut over 30 years ago: it has morphed into something much more tangible, something much more *real*. The wondrous world and familiar characters of *Star Wars* now await fans in the form of toys, books, video games, cartoons, and various other formats that allow fans to engage with the story in ways that the experience of simply watching a film cannot provide.

Fig. 1: Master Yoda's inspirational quotes don many a wall globally.

Star Wars is no longer just something to *watch*, it has become something to *do*, which is one of the key aspects to the very large and sustained fanbase the franchise enjoys. This has resulted, for fans, in ever-increasing connections to *Star Wars* which has, in turn, burgeoned into a phenomenon that wields influence over fans in their daily lives and dominates pop culture, and is clearly evident in our society and global culture as a whole. *Star Wars* has infiltrated our daily lives and is ever present, whether it be the Darth Vader sticker on the car in front of you, overhearing a quote or catchphrase from the film, or getting excited about the official *Star Wars* Day, which occurs on 4 May every year, by the way, and comes with the clever tagline, 'May the fourth be with you'. One of the most fascinating things about *Star Wars* is the extent to which it affects the daily lives of its fans. Fans have, essentially, internalized what *Star Wars* means to them and it becomes a part of who they are. People are drawn to *Star Wars*, and much of this can be attributed to George Lucas' ability to create timelessly appealing characters and a fascinating universe that is familiar despite its unique fictional premise. On the most basic level, *Star Wars* can be interpreted as a battle between good and evil which is, in some aspect, inherent to us all. The showdown between the good Rebels and the evil Empire told with dynamic characters, wrapped in eye-popping special effects, and set in a galaxy far, far away draws viewers in and allows them to sympathize with the characters, and inspires further participation in various ways, as has been explicated throughout the chapters of this book. On a deeper level, *Star Wars* serves as an allegory for many of the other curiosities of our existence: love, politics, religion, gender, race, the list goes on and on. This serves to expand the way fans interpret the saga for themselves and encourages more than its fair share of debate on the meaning of *Star Wars* and, ultimately, how those themes play into our everyday lives.

To further examine the extent of the influence of the Force, we conducted empirical research among randomly selected *Star Wars* fans. Discussions with fans of the saga reveal the varying ways in which *Star Wars* has worked its way into our psyche. When asked whether or not *Star Wars* played any role in his outlook on life, one of the respondents to our survey stated that when he is struggling with something, the words of the venerable Yoda come to his mind: 'Try not. Do. Or do not. There is no try'. These eight words, spoken by a fictional character trying to motivate a young Luke Skywalker, clearly transcend the scene from the movie and have an impact on the real lives of fans; it is not uncommon to see the same quote from Yoda as an email signature or a motto on an office wall, for example.

Many of the characters in *Star Wars* are so dynamic that they leave an unmistakable mark on many viewers. In response to the question about how *Star Wars* affected her, one of our respondents says it best when she recalls that Princess Leia was a positive role model for her as a young girl because, 'I like a smart-ass woman who can shoot a gun, negotiate treaties, pose undercover as a bounty hunter, have two guys fighting over

The Influence of The Force
Jason Davis and Larry Pakowski

Fig. 2 (right):
The Force as Religion.

Fig. 3 (below right):
Lego

her, and still have awesome hair'. Needless to say, viewers of the *Star Wars* saga easily find characters that they identify with, in one way or another, whether it is Luke's youthful exuberance, Leia's toughness or Han's swagger.

As fans begin to identify with the diverse characters of the *Star Wars* galaxy, often through repeated viewings, the fans go from just liking the characters on a superficial level to assimilating their personalities, values and experiences into their own. Rather than just existing as a fictional character on a movie screen, the characters of *Star Wars* exist, to many, as trusted friends to get them through hard times or even as role models to motivate them to new heights. The characters of *Star Wars* and the lessons they learn have influenced countless fans in this way. Not bad for a fairy tale about a princess and her long lost brother set in a far away galaxy!

If we take a step back from the effect of *Star Wars* on individual fans, it is overwhelming to think about the reach of these films. The *Star Wars* phenomenon is not just an American thing, it's not just a youth thing, it's not just a guy thing; instead, *Star Wars* is a franchise that is appreciated and beloved across all imaginable demographics. *Star Wars* has given people of different ages, genders and cultures something in common. Complete strangers from different countries could easily launch into a discussion about their favourite characters or scenes, and could just as easily get into a debate over which film is the best. Everyone, it seems, has seen the films and has an opinion on them. The *Star Wars* franchise has spawned fan clubs, draws fans from all walks of life to conventions, and boasts over 8 million 'likes' on Facebook, which, for those that are counting, still beats the more recent fan craze trilogy *Twilight* and the New York Yankees baseball team. If 'likes' on Facebook does not serve as a valid litmus test for the impact *Star Wars* has on society, consider the detailed explication of the Force as religion in Chapter 7, and the fact that respondents to census questionnaires in numerous English-speaking countries can and do officially report their religion as 'Jedi'. Our society has become inundated with *Star Wars* to the extent that, whether a fan of the franchise or not, most people would recognize a Stormtrooper costume, the catch phrase, 'Luke, I am your father', and would instantly picture a scene from *Star Wars* when they hear John Williams' iconic theme song.

While the impact of *Star Wars* on society is undeniable, the claim it has staked on popular culture stands as one of the most significant feats of any film of any era. Consumers of popular culture cannot escape constant references to, and parodies of, all things *Star Wars*. From the classic *Star Wars* spoof film *Spaceballs* (Brooks, 1987), to the popular cartoon sit-com *Family Guy*'s (1999–) rendition of the *Star Wars* saga us-

Fig. 4:
Family Guy

ing their own characters, to the Cartoon Network's highly popular series *Clone Wars* (2008), *Star Wars* remains an ever present force on the big screen and television. The music world has not escaped the grasp of the *Star Wars* phenomenon, either. The Dutch Symphonic Heavy Metal band Epica's recording and performance of 'The Imperial March' with the Hungarian National Symphony Orchestra remains a crowd favourite on Epica's tours around the world. The *Star Wars* theme song can be heard on 1990s' rap group favourites 2 Skinnee J's song 'Irresistable Force', while rapper MC Chris takes listeners on a clever tour through the *Star Wars* universe in his song 'Fette's Vette'. Philadelphia boasts a rap duo by the moniker Jedi Mind Tricks, and not to be outdone by the hip hop world, we have California indie band Nerf Herder, which, as you may recall, is an insult Leia hurled at Han in *The Empire Strikes Back* (Kershner, 1980) instalment of the films. Recently, the 2012 edition of the Coachella music festival raised some eyebrows when murdered rapper Tupac Shakur made an appearance with Snoop Dogg via a life-sized hologram. While some were left to debate the ethics of using a deceased person's likeness in this way, the Star Wars fan in us all was instantly reminded of the scene from *A New Hope* when Luke stumbles across a hologram message of Princess Leia desperately pleading for Obi-Wan Kenobi's help. And it goes this way for many *Star Wars* fans, the connection or tie in of the *Star Wars* phenomena to things we see in our everyday lives always patiently waiting to be discovered.

Another significant and tangible influence of *Star Wars* on our society is the impact the saga has had on our consumption. As meticulously explained in Chapter 10, the proprietors of the *Star Wars* franchise are doing their best to make sure that consumers buy *Star Wars* and buy it often. The merchandising arm of the *Star Wars* franchise has ensured that there is something for everyone. Any *Star Wars* fan wanting more than to just see the films can buy *Star Wars* books, video games, collectibles and all kinds of *Star Wars* material. If playing a *Star Wars* video game is not enough for the true *Star Wars* fan, she can now purchase limited edition Xbox 360 *Star Wars* console that resembles R2-D2 and comes complete with a controller that looks like C-3PO. As a matter of fact, a search for the term *Star Wars* on Amazon.com returns thousands of results with the first result, logically, being the a complete box-set of the films, but then quickly giving way to video games, books and even a *Star Wars* cardigan sweater. Of course, this mass marketing of all things *Star Wars* results in big profits for the *Star Wars* franchise. According to statisticbrain.com, the *Star Wars* franchise, as of March 2012, had made 27 *billion* dollars.

Of that $27 billion, over $18 billion was revenue generated by the sales of toys, video games and books. These figures show the demand fans have for further interaction with the films and, more importantly, keeps old fans interested in the franchise, while simultaneously tapping into new generations of fans to sustain the franchise for the foreseeable future, as explicitly discussed in Chapter 9.

Beyond the surface, the *Star Wars* franchise reaches farther than its six films and

The Influence of The Force
Jason Davis and Larry Pakowski

Jason Davis and Larry Pakowski

Fig. 5:
From statisticbrain.com.

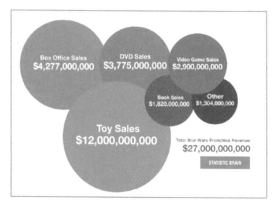

the associated Expanded Universe of merchandise, television specials and series, and literature. The franchise has literally become a culture of its own. The word 'fan' falls far short of describing the devout followers of the saga; instead, the fans have almost a religious connection to greater *Star Wars* universe. From academic study and literal religious identification to spoofs and fan tributes in the various forms of media, the saga did more than spawn a following of its own; it opened the door for its science fiction successors and brought the genre to the masses. *Star Wars* changed the world.

While there are a lot of people who would argue that *Star Wars* is not sci-fi, but rather, space fantasy, there is more than sufficient evidence to argue that the saga is, indeed, sci-fi. Furthermore, one could argue that *Star Trek*, *Stargate* (1997-2007), *Battlestar Galactica* (2004-09), and even programs such as *Lost* (2004-10) and *Fringe* (2008) would not have been as successful if the original

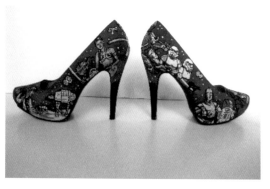

Fig. 6:
Painted heels by
Holly Grothues.

Star Wars trilogy had not paved the way and made the genre to the masses. Even today's blockbuster fantasy franchises like *Harry Potter* (Columbus [2001-02], Cuarón [2004], Newell [2005], Yates [2007-11]) and *The Lord of the Rings* (Jackson, 2001-03) movies would have found difficulty in becoming so successful if it weren't for Yoda, R2-D2, and C-3PO blazing the trail. It was George Lucas who took the original risks that have later inspired film-makers and opened the minds of film executives more openly to ideas based on visions rather than on what has already been done. For anyone unwilling to agree with such propositions, perhaps the numbers explicated in Chapter 10 help back up the bold claim, especially in comparison to the *Star Trek* universe. *Star Trek* (now tabbed 'The Original Series') aired in the late 1960s (1966-69) for three seasons, spawning 79 episodes, followed by a two-season, 22-episode malady known as *Star Trek: The Animated Series* from 1973-74. While both had devoted audiences, neither was considered commercially successful. On 25 May 1977, *Star Wars* premiered in the theatres and changed the game – the film blew the doors open for science fiction on-screen. Since the 1977 release of *A New Hope*, *Star Trek* has spawned eleven feature films (with a twelfth slated for a 2013 release) and four additional television series: *Star Trek: The Next Generation* (1987-94), *Star Trek: Deep Space Nine* (1993-99), *Star Trek: Voyager* (1995-2001) and *Star Trek: Enterprise* (2001-05), which have collectively brought forth 624 episodes to rousing critical and commercial success. While the true impact of *Star Wars* on the viewing audiences' preferences and studio executives' minds may not be possible to measure, it is legitimate to suggest that perhaps Captain Jean-Luc Picard would not have dared to 'boldly go where no one has gone before' without *Star Wars*

first opening the doors for science fiction to be readily accessible and palatable to the masses, and becoming so successful financially. With regard to other film sagas, the influence and inspiration of Lucas to future film-makers has been explicitly stated in various interviews over the years, including the ones made for the DVD release of all six episodes.

However great one believes the influence of *Star Wars* in the realm of science fiction has been is obviously a matter of personal opinion based on the evidence and support available. The role of the saga in the world of science fiction has been a topic of discussion and debate for long, more recently coinciding and inspired by the George Lucas episode of the TV series *Ridley Scott's Prophets of Science Fiction on* Discovery Science Channel, in which Lucas was featured alongside sci-fi authors as a popular culture author/director whose works have inspired real-life science. While the Lucas episode clearly demonstrated the scientific elements in Lucas's saga and introduced a variety of interesting scientific discoveries directly related to *Star Wars*, the detractors of the saga continued intense online debate over whether or not Lucas was worthy of inclusion in a show featuring 'prophets' of sci-fi.

When measuring the impact of anything on anyone, we turn, of course, to the academia. In the past 40 years, academic interest into non-canonical or unconventional subjects has become more and more common; for example, *Harry Potter*, the *Lord of the Rings* trilogy, and the music of Tupac Shakur all have courses dedicated to their study at some of the world's most prestigious universities. However, one would be hard-pressed to find a subject meriting a broader spectrum of study than the *Star Wars* franchise – like the space the narrative is set in, it is limitless. Therefore, it is no wonder that *Star Wars* has, indeed, inspired college faculty around the world to teach cultural studies and film studies classes on the saga.

To the layperson, this kind of study involves viewing six films in succession, but of course, the study of the saga is far more complicated. To truly approach the saga, academics delve into the entire greater universe. For instance, one could examine the father-son dynamics between Luke and Vader or the Jedi Master and his Padawan apprentice, or perhaps the themes of religious and political strife in the films as an allegory for the Cold War political climate present during Episodes IV–VI, or even the ways in which real, modern technology seems to draw inspiration from the tools, gadgets, and scientific principles present in the films – and that's just scratching the surface. In a large way, this is because George Lucas' universe is so intricate and complicated. One could study the saga through nearly any lens because there are so many elements of what define the locations, characters, and narrative. Academia continues to raise new questions and investigate the elements of the saga, and works such as this one evaluate and theorize about the impacts and meanings of *Star Wars*.

Numerous elements of *Star Wars* have been met with stark academic inquiry, and as is typical of academic study, scrutiny of *Star Wars* has not only led to further insight

The Influence of The Force
Jason Davis and Larry Pakowski

and interpretations of the saga, but also to criticism. All we have to do is look at Jar Jar Binks. As we learned in Chapter 8, for example, when *The Phantom Menace* (Lucas, 1999) was released, film critics and fans alike cried foul, labelling the character a stereotypical, racist rendering of Caribbean/African American culture. Academics take this analysis even further, seeking to dig deeper to understand the deeper sociological implications of the character, and the rationale of Lucas and his team in creating such a controversial character to a saga of beloved characters. Much has been said about other sociological elements of the saga, including Luke's patricide, the brother-sister relationship between Luke and Leia, and the religious elements of the saga, and the fact that very few elements in *Star Wars* seem to be linear ensures continued academic interest in the saga's disparate sociological and cultural subtopics.

Fig. 7:
Millenium Falcon guitar created by Tom Bingham of Corby, Northamptonshire (UK).

Beyond the academic level lays the spiritual and religious aspects of the saga, illustrated in more detail in Chapter 7. For years, there has been an actual religious movement, predominantly in English-speaking countries, known as 'Jediism'. Declaring to belong to the 'Jedi Church', the followers of the movement are not mere 'super fans' of the saga, they are actual religious followers of the teachings and ideals of the Jedi exhibited in the films and greater *Star Wars* universe. Besides movements in no fewer than a dozen nations worldwide to have Jediism recognized by each nation's census bureau, there has even been a near decade-long fight for the United Nations to officially recognize the faith.

When it comes to the greater *Star Wars* universe and the fan phenomenon associated with the saga, not all forms of *Star Wars* affection are as serious as topics within the confines of academia and religion. Another key element of the fandom is the numerous spoofs and tributes Lucas' saga has inspired over the years. Though they are true polar opposites in virtually every way, both spoofs and tributes heighten the popularity of the films.

In regards to spoofs, there are countless examples to draw from. From *Saturday Night Live* sketches to Weird Al Yankovic's 'Yoda' and 'The Saga Begins', satire has a place in this conversation. Without a doubt, the best example of a *Star Wars*-inspired spoof came in the form of *Spaceballs*, a 1987 Mel Brooks film poking fun at the Original Trilogy which earned more than $38 million. Even *The Muppet Show* (1976–81) brought viewers its own *Star Wars* spoof. Part of what makes this aspect of the fan phenomenon so special is the enduring nature of the spoofs. In the first decade of the twenty-first century, we have seen *Chappelle's Show* (2003–06) spoof Yoda and the Jedi Council in a juxtaposition to the Catholic church's problems with molestation charges, *Spaceballs* become an animated series on American network G4, and *The Howard Stern Show* relentlessly poke fun with phony phone calls using the voice of a convention attendee who identified himself to show staff as Darth Nihilus. The plot of the 2008 film *Zach and Miri Make a Porno* (dir. Kevin Smith) even revolves around the making of a *Star*

Wars-inspired pornographic film-within-the-film entitled *Star Whores*. The Organic Trade Association has even created a 2005 YouTube sensation entitled 'Store Wars' which recasts the characters of the saga as common supermarket produce and other items fighting for the righteousness of organic produce and products.

Conversely, there has also been a great deal of *Star Wars* tributes, especially as of late. Going beyond poking fun and instead paying homage to the saga, these tributes may still have a humorous undertone, but they are not intended as spoofs. One quite amazing tribute is the Yoda and Darth Vader voice downloads available for Tom-Tom, the American GPS car navigation system. Videos on YouTube about the supposed recording in the studio with Yoda and Vader are immensely popular entertainment, spoofs of sorts promoting forms of tribute. *Family Guy* and *Robot Chicken* (2005–) have both presented viewers with Lucas-approved tributes, retelling the stories of the saga in the vein and vernacular of their own show's universes. One would be remiss to not mention fanfiction and conventions in this regard; both hold huge places in the tribute aspect of fan phenomena. So much so that both merit study on their own, as explained carefully in Chapter 4.

In the end, when we consider the influence of the Force holistically, we must conclude that it is a tribute to the breadth and depth of Lucas' narratives that so many different aspects of fan phenomena exist within the *Star Wars* universe. As the various topics discussed in the chapters of this book demonstrate, popular culture worldwide would not have been the same without the saga, and for that same reason, *Star Wars* is still a large part of the culture today. In 1977, the first *Star Wars* was a once-in-a-lifetime experience. 35 years on, it is a phenomenon that endures and impacts generation after generation. ●

GO FURTHER

Extracts/Essays/Articles

'Jedi knights put their faith in the census' Edin Hamzic
In *Sunday Times*, 14 May 2012, p. 3.

'Star Wars and its spoofs' Christian Blauvelt
In *Entertainment Weekly*, 27 May 2011, p. 16.

'*Star Wars* vs. *Star Trek*: The final frontier of marketing is an expanding universe'
John Wenzel
In *The Denver Post*, 11 October 2009,
Available at: http://www.denverpost.com/entertainment/ci_13518101

The Influence of The Force
Jason Davis and Larry Pakowski

'Great Geek Debates: *Star Trek* vs. *Star Wars*'Matt Blum
At 'Wired.com', 5 Aug 2009,
Available at: http://www.wired.com/geekdad/2009/08/great-geek-debates-star-trek-vs-star-wars/

'The dark side of academia; Star Wars: A force to be reckoned with in higher thought'
Eric Volmers
In *Guelph Mercury (ON)*, 19 May 2005, p. A1.

'*Star Wars* vs. *Star Trek*'
David Ewalt
In *Forbes*, 18 May 2005,
Available at: http://www.forbes.com/2005/05/16/cx_de_0516match.html

'Store Wars'
The Organic Trade Association, 2005,
Available at: http://www.youtube.com/watch?v=pUi43BCrsH0&feature=related

'The Saga Begins'
Al Yankovic
(Volcano Entertainment, 1999)
Available at: http://www.youtube.com/watch?v=hEcjgJSqSRU&ob=av2e

'Trekkers vs. Lucasites'
Richard Ho
In *The Harvard Crimson*, 14 May 1999,
Available at: http://www.thecrimson.com/article/1999/5/14/trekkers-vs-lucasites-pin-the-absence/

'Yoda'
Al Yankovic
(Scotti Brothers, 1985)
Available at: http://www.youtube.com/watch?v=xMpDHEVal1k

Interviews

Personal interview Ryan Streeter, 22 April 2012.

Personal interview with Dana McKoy,
20 April 2012. Photo source *(Star Wars Total Franchise Revenue)*: http://www.
statisticbrain.com/star-wars-total-franchise-revenue/

Contributor Details

EDITOR

Mika Elovaara, Ph.D., is an author, teacher, coach, a former professional athlete and a life-long fan of *Star Wars*. He was born on Hoth (or Finland) but currently resides in the United States. His work on *Star Wars* includes teaching sessions on the saga at Finnish high schools, developing and teaching a graduate level class on *Star Wars* at UNC Wilmington, and appearing as an expert guest on the George Lucas episode of the TV show, *Ridley Scott's Prophets of Science Fiction*. He has published a variety of works, from encyclopedia articles to ESL textbooks and research monographs, and is currently working on two extensive research monographs. Among his numerous duties, he serves as a board member and reviewer for the *Journal of American Culture*. Currently, Dr. Elovaara enjoys full-time coaching, independent research and writing.

CONTRIBUTORS

The *Star Wars* saga has a special place in **Brendan Cook**'s (MA) heart, since he spent several years living on Tatooine (spelled Tunisia) while growing up. Since then, he has studied martial arts, Zen Buddhism, history, religion and theology, acupuncture and oriental medicine, as well as popular culture. As a boy, he had only a moderate collection of *Star Wars* action figures and vehicles, none of which survived to the present day. His appreciation for the epic has stayed with him over the years and, as the father of three younglings (with one on the way), he has sought to pass on that love to the next generations. Based on the number of lightsaber battles he has to referee, he has been somewhat successful. And the *Star Wars* toys he buys are for the kids...only for the kids.

Jason Davis is a life-long *Star Wars* fan who works in student affairs at the University of North Carolina Wilmington. He holds a Bachelor of Arts in Sociology from North Carolina State University and a Master of Arts in Liberal Studies degree from UNCW. He lives in Wilmington, NC with his wife Kate.

Jonathan Miles DeRosa (MA) is a film-maker, comic, and proud advocate of the 'Do It Yourself' spirit. His love and admiration for the *Star Wars* universe grew from his father's introduction to the series as a young boy. A former event planner, he has done marketing for various companies, including the IBM Watson project. He studied improvisation for years at an assortment of schools, including Chicago's Second City. His film, *The Thing About My Brother* was completed in 2012. He was once featured in *Rolling Stone* for complaining about how they put the cast of *The Voice* on the cover instead of Etta James after her passing. Oh, and he knows Han shot first.

Zachary Ingle is a Ph.D. student in film and media studies at the University of Kansas. He holds degrees from Howard Payne University (BA), Baylor University (MDiv) and North Carolina A&T State University (MA English). Ingle has published articles and reviews in *Literature/Film Quarterly*, *Mass Communication and Society* and *Journal of American Culture*, among others. He edited *Robert Rodriguez: Interviews* (University Press of Mississippi, 2012) and is currently co-editing an anthology on sports documentaries for Scarecrow Press. He has contributed to several Intellect books, including the *World Film Locations* volumes on Paris, Las Vegas and Marseille, and the *Directory of World Cinema* volumes on Sweden and Belgium. His research interests include African American and Chicano cinema, as well as religion and film. But perhaps his greatest accomplishment was being first in line to see *The Phantom Menace* at the theatre in Brownwood, Texas.

Kristopher Jacobs is a traveller, a marathon runner, a writer, and a very bad dancer. He studied literature and philosophy as an undergraduate at the University of North Carolina Wilmington, and in 2008 he received a Master of Arts in Liberal Studies from that same institution. Since then, he and his wife Debra, a photographer, have travelled extensively throughout Europe, North America and the Caribbean, and are collaborating on a book showcasing their adventures. Kristopher is also currently working on a collection of short stories and is nearing the completion of his first novel.

Marc Joly-Corcoran is a Ph.D. candidate in film studies, part-time lecturer at the University of Montreal, and film director. His research is concerned with popular cultures, reception studies and religious studies. He is working on framing a new theory to explain how the 'first affective movie experience' may trigger subsequent cultural reappropriations. He published articles in French literatures, and gave several papers in international panels (Istanbul, Salzburg, Rotterdam and LA). He also produced and directed a short movie titled *The Piece Coin*, already selected in several festivals (such as Montréal, Boston, Rhode Island and Ireland).

Sarah Ludlow is an independent researcher based in the north-east of England. She has recently completed her second master's degree, having successfully attained an MA in Modern and Contemporary Studies and then an MRes in Gender Studies at Newcastle and Northumbria Universities respectively. Her chosen research areas centre largely on fan cultures and fanfiction, and her continued involvement in and love of online writing cultures has influenced a sizeable proportion of her research. In keeping with her 'acafan' sensibilities, her final dissertation was entitled 'Re-Imagining the Masculine: Gender and Production Politics in Online Fan Fiction' and was the recipient of the Best Dissertation Award at Northumbria University in December 2011. When not writing, Sarah can often be found scouring online fiction archives and lurking in writers' forums, searching for that next, as yet undiscovered, fanfiction classic.

Neil Matthiessen is a graphic designer, artist and assistant professor at University of South Florida St. Petersburg. Matthiessen worked as a professional design for over a decade and has exhibited in the United States, Europe and Asia. Matthiessen's research has focused on popular culture and technology.

Larry Pakowski (MA) is a life-long *Star Wars* fan. Larry was exposed to the original trilogy at a young age and has since become enthralled with the additional films and greater universe as well. A native of Greenville, North Carolina, Pakowski now resides in Wilmington, and just finished the manuscript for his first full-length novel.

Dr Jason Scott is a senior lecturer in film studies at Leeds Trinity University College. His current research focuses on the historical development of the character-oriented franchise in film and related media. His research on *Star Wars* fandom provides an alternative account of the character-oriented franchise in his chapter 'From Behind the Masks to Inside: Acting, Authenticity and the Star Wars Co-Stars' in *Cult Film Stardom: Offbeat Attractions and Processes of Cultification* (Kate Egan and Sarah Thomas [eds], Palgrave Macmillan, forthcoming).

Erika J. Travis is an assistant professor of modern languages and literature at California Baptist University. Her research and teaching interests include Victorian novels, children's and young adult literature, science fiction and fantasy. She fell in love with *Star Wars* watching edited-for-television versions as a girl, and has since incorporated her love of the saga into everything from Halloween costumes to scholarly research. When she is not working, she's enjoying her life as a 'Leia-mom' with her two young children and 'Han-husband'.

Image Credits

From *A New Hope*

Inside covers
Introduction: Fig. 1 p.5
Chapter 2: Fig. 1 p.23

Additional Images

Introduction: Figs. 1 and 2 p.7 © Mika Elovaara
Chapter 1: Fig. 1 p.16 Courtesy of Tracy King
Chapter 2: Fig. 1 p.21 © http://bit.ly/frOhaN
 Fig. 4 p.25 © Adam Works
Chapter 3: Fig. 1 p.30 © Letter from Maureen Garrett to publishers of *Star Wars* fan
 zine, 1981. www.fanlore.org.
 Fig. 2 p.31 © cover art for 'About Turn', by Mina
 Figs.3-4 p.32 © Rachelle Porter
 Fig. 5 p.33 from *TROOPS* (dir. Kevin Rubio)
 Fig. 6 p.33 from George Lucas in Love (dir. Joe Nussbaum)
 Fig. 7 p.34 from Quentin Tarantino's *Star Wars* (dir. Evan Mather)
 Fig. 8 p.34 from Ryan vs. Dorkman (dir. Ryan Wieber and Michael Scott)
 Figs.9-10 p.36 from The Formula (dir. Chris Hanel)
 Fig. 8 p.33 from Ryan vs. Dorkman (dir. Ryan Wieber and Michael Scott)
Chapter 4: Fig. 1 p.42 © 1997 Lucas Arts
 Fig. 2 p.44 © IGN and Lucas Arts
Chapter 5: Figs. 1-4 pages 49, 50 & 53 © www.heruniverse.com
Chapter 6: Fig. 1 p.61 © Open Court Publishing Co.
 Fig. 2 p.62 © Dark Horse Comics
 Fig. 3 p.63 © Nelvana, Lucasfilm
 Fig. 4 p.64 © Homepage of www.templeofthejediorder.org
 Fig. 5 p.64 © Homepage of www.jedichurch.org
Chapter 7: Fig. 1 p.69 © http://bit.ly/16wNp9t
 Fig. 2 p.71 © http://bit.ly/133OTLT
 Fig. 3 p.72 http://bit.ly/17aW4zv
 Fig. 4 p.73 © Will Brooker, cover of "Using the Force". Retrieved from
 http://bit.ly/14uLnVX
 Fig. 5 p.74 ©http://bit.ly/4fj3OA
Chapter 8: Fig. 1 p.79 © David W. Creighton 1983, 2004 www.idexter.com
 Fig. 2 p.81 © Timothy Zahn, cover of "Heir to the Empire".
 Figs. 3-4 p.82 © http://www.starwarstoymuseum.com
Chapter 10: Fig. 1 p.99 © Mika Elovaara.
 Fig. 2 p.100 © Rik Henderson / Pocket Lint. Retrieved from http://yhoo.it/1331Wvo
 Fig. 3 p.100 © www.videogamesblogger.com
 Fig. 4 p.100 © http://www.videogamehollywood.com/?p=1429
 Fig. 5 p.102 http://www.statisticbrain.com/star-wars-total-franchise-revenue/
 Fig. 6 p.102 http://www.bitrebels.com/geek/star-wars-heels-for-all-you-geeky-girls/
 Fig. 7 p.104 http://www.egotripland.com/star-wars-guitars/

READY ARE YOU?
WHAT KNOW YOU OF READY?
FOR EIGHT HUNDRED YEARS HAVE I TRAINED JEDI. MY OWN COUNSEL WILL I KEEP ON WHO IS TO BE TRAINED.

YODA
THE EMPIRE STRIKES BACK